"When you take a flower in your hand
and really look at it, it's your world for the moment.
I want to give that world to someone else."

ARTIST GEORGIA O'KEEFFE

Publisher: BLOOM Imprint

Author + Editor: DEBRA PRINZING

Creative Director: ROBIN AVNI

Designer: JENNY MOORE-DIAZ

Copy Editor: JUDITH H. DERN

Image Editor: HEATHER MARINO

Cover Photography: ROBIN STUBBERT

BLOOM Imprint
4810 Pt. Fosdick Drive NW, #127
Gig Harbor, WA 98335

ISBN: 978-1-7368481-0-4
Library of Congress Control Number: 2021934998

www.bloomimprint.com www.slowflowerssociety.com

Printed in the U.S.A.

where we bloom

debra prinzing

THIRTY-SEVEN INTIMATE, INVENTIVE, AND ARTISTIC STUDIO
SPACES WHERE FLORAL PASSIONS FIND A PLACE TO BLOSSOM

foreword by emily thompson

dedication

TO FLORISTS, DESIGNERS, GROWERS, AND ARTISTS EVERYWHERE.
MAY YOU FIND YOUR OWN SPECIAL PLACE TO BLOOM!

table of contents

ROBIN STUBBERT PHOTOGRAPHY

foreword

COLLABORATION WITH
THE ROUGH HAND OF NATURE

emily thompson

People who work with flowers are acutely attuned to the living world and its weather. The tiny shifts in the season — what changes are wrought with every passing hailstorm or fog — register in our eyes and our hands. Cognizance of the most ephemeral aspects of our environments is quite normal and natural to us, and for this precise reason, our sense of place is heightened.

For those of us who have made this our life's work, creating a sense of place is central to our practice. Our challenge is to bring that misty morning to the most stubbornly bland interior space — to inhabit the walls built to shelter us from the weather with, well, the living embodiment of the weather.

"For those who have made this our life's work, creating a sense of place is central to our practice."

How do we orient ourselves in space? A place may have fixed coordinates, but it can be transformed from tundra to meadow and back with each cycle. And haven't the continents themselves pulled apart? I'd argue that flowers can locate us as effectively as a compass. Exactly where are we? The flowers insistently proclaim: "You are on the earth; you are of the earth."

Over the dozen or so years I've been immersed in flowers, I've made work in countless spaces and made my studio in many others. Often, the workspace is a loading dock, or the back of a truck, or even, at times, a sidewalk of New York. The various miseries of these exposed and shared environments also engender moments of bizarre elation and absurdity; they can bring human connection and conflict.

The HQ is another beast altogether. This is the place where my team and I return from our forays and installations to share food and stories of what new affronts and hurdles we've negotiated in the urban jungle. I call it the Temple. We are building a Temple, I say. And while the Temple is really an idea, our studio is where the idea is most powerful — a place where we distill our offerings to our medium, glorifying the natural world in all its slimy, thorny variations. It's a refuge, a commissary, a library, and a laboratory. It is never fixed, always changing along with its living contents. In some ways, it, itself, is alive.

The environments you see here in the pages of *Where We Bloom* are as unique to these floral artists, flower farmers, and designers as is my studio space, and each is part of the maker's practice. May you find yourself lost in their stories and the environments that contain their craft.

Emily Thompson was raised in the Northeast Kingdom, Vermont, a place of uncompromising beauty. She brought her sense of this place, its ruins, and its wilds, to her work as an artist, traveling from the Pennsylvania Academy of Fine Arts, the University of Pennsylvania, to UCLA, where she earned her MFA in sculpture, finally landing in New York City. Here, she fell in with a rough crowd of thorny brambles and made it her mission to bring them to light. Emily is the owner and creative director of Emily Thompson Flowers, based in New York City.

introduction

debra prinzing

What is it about devoting square-footage in which to contain our passions?
I've been intrigued by this concept for decades, beginning with my 2008 book,
Stylish Sheds and Elegant Hideaways. Painters have their ateliers, gardeners have their
greenhouses, writers have their nooks. The "where" in *Where We Bloom* is as important as
the "we bloom," and that's what this book explores.

Here is the central question: Is the environment in which you make floral magic an
integral part of the creative process? Do your surroundings enhance your art?

Of course, if there is enough passion driving your desire to grow cut flowers or to
arrange stems into a lovely composition, the "place" may not matter. We know this
because creativity and art making can and do occur literally anywhere: At the kitchen
counter, inside a garage filled with bicycles, at a makeshift table fashioned out of
sawhorses and a sheet of plywood. So maybe instead I should ask: "What does your
ideal design space look like in your imagination?" If you can fix your gaze on the studio,
workshop, storefront, or greenhouse that exists in your mind's eye, while also living and
working in the moment, I'm confident that dream can become a reality.

The romance of devoting space to the pursuit of one's art isn't lost on the flower farmers,
designers, and florists whose stories are shared here. While my interviews often began
with practicalities such as dimensions, materials, finishing details, and furnishings — all
specifics I wanted to share with readers — our conversations inevitably turned to

"The romance of devoting space to the pursuit of one's art isn't lost on the flower farmers, designers, and florists whose stories are shared here."

intangible ways a space is beloved. Creatives described to me how they feel a boost of
emotions upon walking through the doorway of their studio or arriving at a pavilion or
greenhouse in the garden, their arms laden with bunches of just-picked blooms. Leaving
the digital world behind, they embrace the physical and sensory act of holding flowers in
their hands, fully immersed in their craft.

Feeling an emotional connection to one's dedicated floral environment is a common
thread flowing through the pages of *Where We Bloom*. Conjured by women and men
who occupy these charismatic studios, workshops, greenhouses, barns, flower trucks,
and, yes, sheds, botanical art is surely elevated — due in no small part to the setting's
uniqueness. Each environment inspires individual expression, echoes one's floral aesthetic
and communicates the "brand" of a floral enterprise. *Where We Bloom* nurtures the work
of growing and harvesting, gathering and arranging, and ultimately, communicating
human senses and emotions through the medium of flowers.

Of course, it's my desire you will experience these feelings in your own botanical
milieu. Feel welcome here, as you discover thirty-seven intimate and inventive floral
environments, from those in urban hubs to more remote settings. Some are architectural
gems, others are diamonds in the rough. All are perfect examples of how and where to
contain one's floral passion and purpose. Inspired by their owners and creators, each of
these botanical getaways invites you to answer the question: Where Do You Bloom?

modern homestead

A HORSE BARN CONVERTED WITH FUNCTION AND BEAUTY IN MIND

Lori Poliski, Flori Flowers

Woodinville, Washington

flori.flowers, @flori.flowers

Missy Palacol Photography

"I wanted this whole space to be totally flexible. The tables can be wheeled outside when we want to work under the canopy."

Lori Poliski was a gardener long before she formed Flori, her design studio based in a suburb of Seattle. She has made posies and arrangements since she was five, drawing from roots that began on a family farm in New Jersey where her mother grew lilacs, peonies, and roses. Lori worked for a flower shop in the Bay Area after college; later, during a technology career, she continued to design flowers for family and friends' weddings.

In 2017, she formalized as a business, naming the studio "Flori," from the Latin *florus*, which means 'flower' and rhymes with her name. "My husband designed my first business card and it read: 'Garden-style flowers for small weddings and events.'"

The frustration of producing wedding flowers in a garage filled with sports equipment and bicycles inspired dreams of having a dedicated design space. Lori's solution? A 12-by-24-foot covered storage area at one end of the horse barn where three animals also are stabled.

The space now has two sets of white French doors and windows, which look charming against the blue-gray shingle siding, complete with a striped awning.

Lori cleaned diesel and oil stains off the concrete floor, coating it with

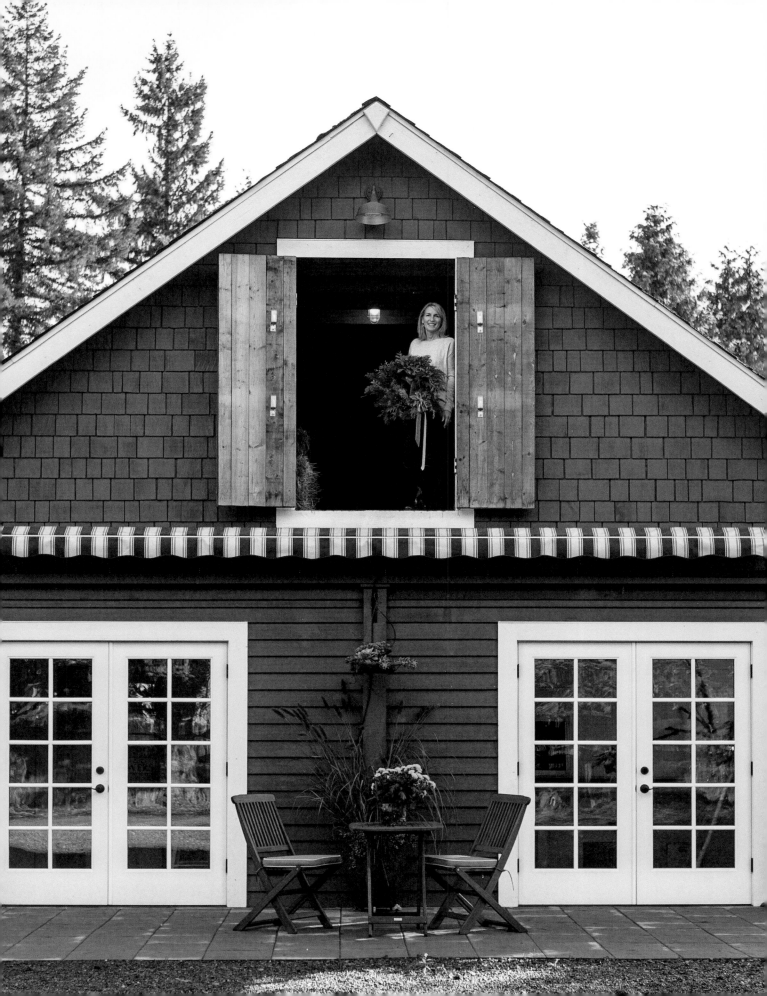

"I'm encroaching on the horse pasture for my dahlias!"

a non-toxic finish. She covered the walls with horizontal shiplap siding, installed a tongue-and-groove cedar ceiling alongside a weathered structural beam, and invested in modern-industrial lighting. There is a tiny bathroom and a large sink for filling vases (the horse-washing station outside the barn does double-duty for filling flower buckets).

Lori's husband and a handyman took care of the carpentry, including making long worktables, the tops of which are from repurposed barn-slider doors. "I wanted this whole space to be totally flexible," she explains. "The tables can be wheeled outside when we want to work under the canopy or hold workshops."

Lori also converted an adjacent 12-by-18-foot storage shed into a walk-in cooler with a CoolBot system, perfect for storing just-picked flowers harvested from her cutting garden or brought home from flower farms in her area. The Flori cutting garden encompasses one half of the two-acre property, including eight-foot perennial borders that surround her home and a set of one-dozen galvanized feed tanks that that serve as raised beds where a children's play structure once stood. Her greenhouse is nearby, allowing for on-site flower processing when Lori harvests spring tulips, daffodils, and butterfly ranunculus. As for expanding the percentage of flowers that she grows herself, Lori confides: "I'm encroaching on the horse pasture for my dahlias!"

She feels spoiled by the abundance of her garden. "My favorite thing to do in spring, summer and fall is to go cut a bucket from my garden and design from this bounty. It's seasonal, it's fresh," she says, smiling.

"My favorite thing to do in spring, summer, and fall is to go cut flowers from my garden and design from this bounty."

floral immersion

CONNECTING NEW YORKERS WITH NATURE

Taylor Patterson, Fox Fodder Farm

Brooklyn, New York

foxfodderfarm.com, @foxfodderfarm

Nicole Franzen Photography

"I want people to enter the environment we've created here and just relax."

Taylor Patterson's aesthetic is lush, elegant, and seasonally inspired. Her floral enterprise evolved from a Brooklyn Flea stall where she sold plants in Mason jars a decade ago into a studio and shop serving weekly business accounts (restaurants, coffee shops, and retailers), offers local floral deliveries, and designs for weddings and special events.

The daughter of two "plant geeks," Taylor borrowed Fox Fodder Farm's name from the small Delaware farm where she grew up. Having the word "farm" associated with her floral design business allows Taylor to educate employees and clients alike about her local and seasonal flower sourcing practices.

Today, Fox Fodder Farm resides in an 1,800-square-foot design studio and storefront in Brooklyn's Williamsburg neighborhood. Taylor co-designed the sunbathed space with landscape architect Brook Klausing of Brook Landscape. "We spoke the same language in terms of how I wanted it to feel and what materials we used — stone, reclaimed wood, concrete," Taylor says. "I want people to enter the environment we've created here and just relax."

The shop feels like a plant-filled courtyard garden. There's a soothing splash from an in-ground stone water feature. Cut flowers line the

textured walls and organic shelving displays products by favorite artists and artisans.

Fox Fodder Farm's branding values transparency, which means customers know where their flowers come from. That may be California, Japan, or Holland during the off-season. By late spring, though, Taylor turns to growers in her region, including those in the Hudson Valley and on Long Island, as well as from wholesalers at New York City's Flower District who support her mission. "I want our sales to be based on this community of clients who value the unique flowers we procure," she explains. "That's how I am when I buy flowers from various suppliers and farms."

Taylor also wants floral choices to remain affordable and accessible, which means she's decided to take a smaller markup on flowers, compared to other items she sells, such as gifts or accessories. "I want people to not be afraid to buy flowers, so we're pricing flowers to draw people in," she explains. Taylor dreams that her new shop in Williamsburg will expose more urban dwellers to the allure of local and seasonal flowers and to nature itself. The interior space is versatile, similar to a restaurant's open-kitchen concept, inviting customers to see staff designers create foam-free arrangements or to select stems and a vase to make their own arrangement. Using botanical beauty to influence sustainable choices and talk about ethical flower farming distinguishes Fox Fodder Farm in a crowded marketplace. "I want to help people shift the way that they perceive flowers," Taylor says.

"I want our sales to be based on this community of clients who value the unique flowers we procure. "

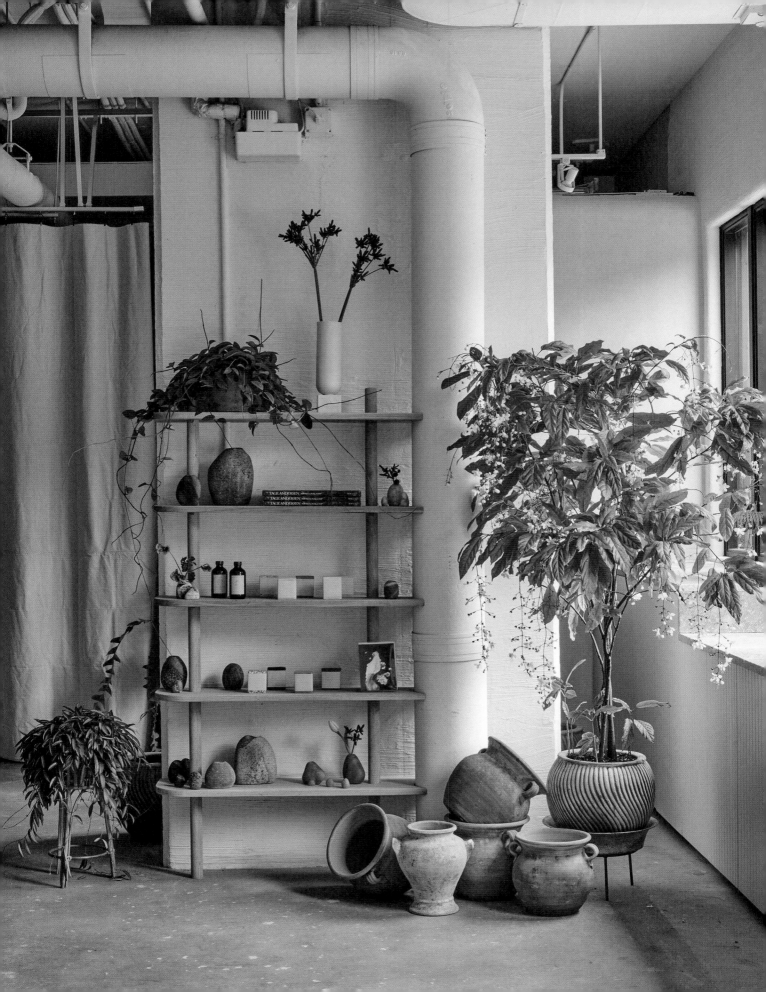

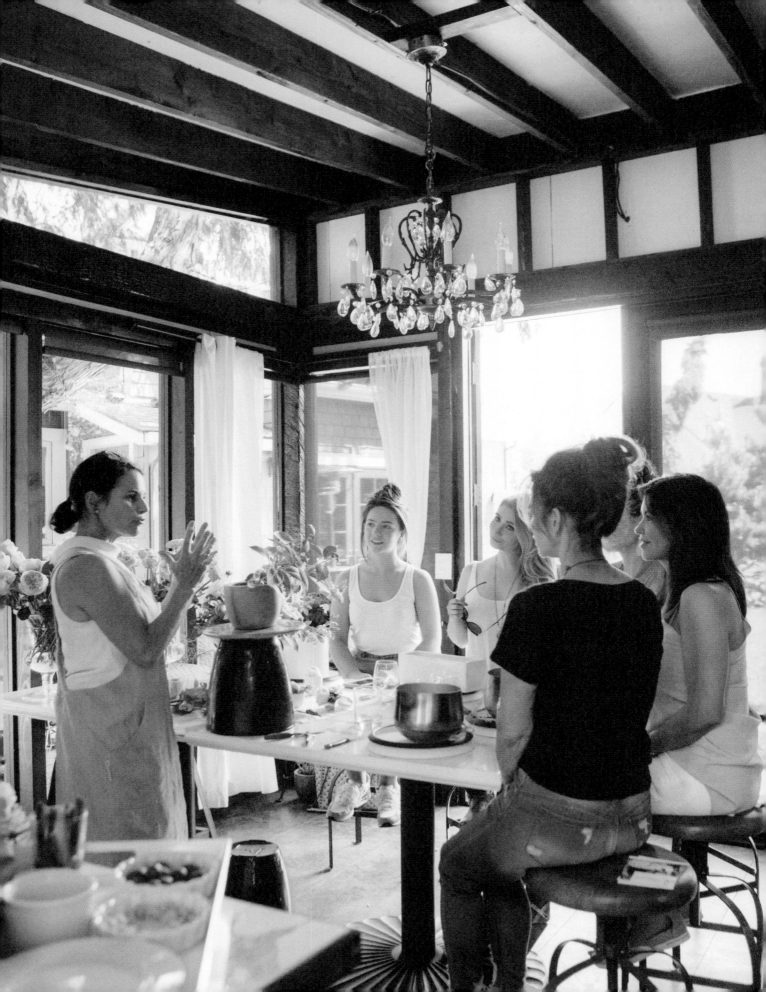

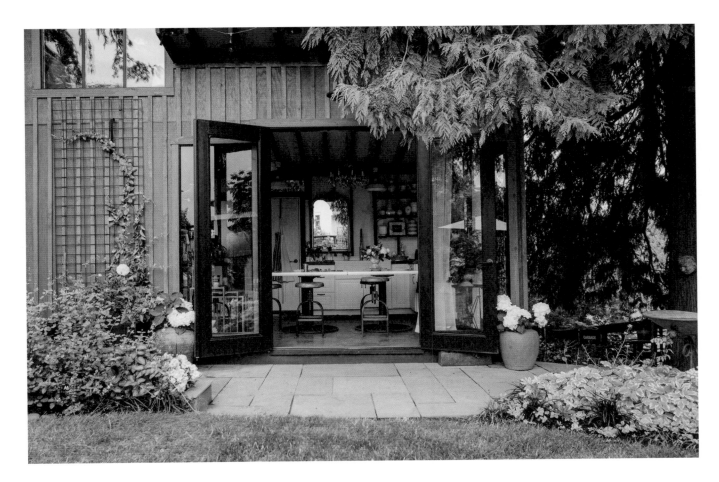

backyard room of her own

HER ATELIER IN THE HEART OF A CITY GARDEN

Maura Whalen, Casablanca Floral

Seattle, Washington

casablancafloral.com, @casablancafloral

Alessandra Brescia Photography

"I can create a design, walk away from it, amble through my gardens and find that little extra something to add to my piece."

When Seattle florist Maura Whalen started Casablanca Floral as a subscription-based studio serving homes and businesses, she used her children's tree fort, a mere 36-square-foot space barely large enough to hold a wreath-making machine. She later graduated to a shed, working among tools, garden supplies, and sports equipment.

Maura weighed the options of leasing a retail shop or sharing a studio with another designer, but two things happened instead. First, her teenage daughter, Claire, sketched an artist's studio, saying: "Mom, you have to get out of the garden shed." Second, while taking a workshop with famed designer Ariella Chezar, Maura mentioned her choices. "We had a lovely chat about it," she recalls. "Ariella told me I had a great story and having my own design space would make my story come alive. Her encouragement was exactly what I needed."

The design and construction of Casablanca's 220-square-foot studio was a collaboration between Maura and bespoke builder Pete Tabor of The Richochet Lab. Tabor used a chainsaw to distress the exterior siding, hunted salvage yards for hardware and table bases and hauled a boulder from another client's property to anchor a corner post. Inside, there are counters, worktables, a vintage chandelier that Maura found for $45, and a captain's ladder leading to a loft space. There are live flowers cast in resin and embedded in the long-grain fir ladder.

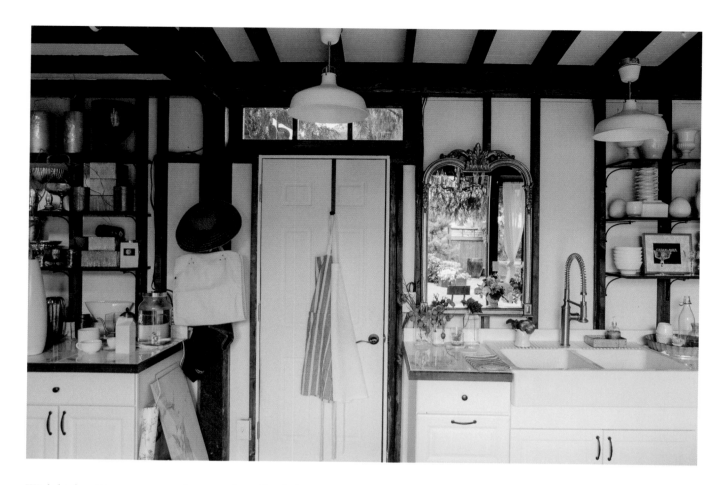

With high ceilings, two greenhouse-style walls of glass and an outdoor deck for staging buckets of just-picked flowers, the studio is nestled beneath two century-old cedar trees, which provide cooling shelter in the summer and make Maura feel like she's back in her kids' tree house.

"It's not uncommon for me to come into the house having worked in the studio for hours and say, 'I love my studio; I love my job,'" she confides. "The light is fantastic, and I feel like the cedars are hugging me or dancing with me as I create." Together, the studio and cutting garden play the role of Maura's design muse: "I call it 'Brooklyn-meets-Paris.'"

Diminutive in square footage, the studio feels "just right" for Maura's needs. "It works for me; it works for the intimate classes I teach," she says. "I can create a design, walk away from it, amble through my gardens and find that little extra something to add to my piece. And usually, it's not a typical ingredient for a typical floral arrangement. I really love mixing the classic florals with foraged finds — and most of them come from the garden." This practice allows Maura to stay hyper-local and hyper-seasonal in her design work.

"I think that so much of the creative process is helping people to unwind and unleash. So that's how I design my classes. I believe we are all artists inside and we just need to suspend judgment of ourselves and others and let the ingredients speak to us. If you pour love into it, just like cooking, you're going to create a beautiful piece."

"It's not uncommon for me to come into the house having worked in the studio for hours and say, 'I love my studio; I love my job'."

arizona in bloom

A HIGH-DESERT FLOWER FARM FLOURISHES

Aishah Lurry, Patagonia Flower Farm

Patagonia, Arizona

patagoniaflowerfarm.com,
@patagoniaflowerfarm

Kayla Simpson Lewis Photography

"The idea of germinating and growing something is so magical to me."

Sixty miles east of Tucson, and 25 miles north of the U.S.-Mexico border, Aishah Lurry nurtures a year-round "micro" flower farm named after her hometown of Patagonia, population 1,000. While some may think it's impossible to grow cut flowers here, Aishah explains that the high desert location (4,000 feet above sea level) is surprisingly ideal for floral agriculture. "One of the benefits about living here is that our ground never freezes and the soil is always workable."

Aishah, with her husband Sebastian, came to this old mining town filled with artists and retirees to work at a retreat center. She grew sprouts and taught workshops to guests; he ran the organic vegetable garden. Four years ago, feeling burned out and in need of a change, Aishah quit her job, cleared a field where they lived and planted flower seeds. "I needed to express myself artistically," she explains. The simple act reminded her of carrot and radish seeds her mother gave her as a child. "The idea of germinating and growing something is so magical to me."

Aishah's search for creative fulfillment evolved into Patagonia Flower Farm. "Originally, I just wanted to walk out my door and see a field of blooms. Then, I had too many flowers and I needed to share them with others," she says.

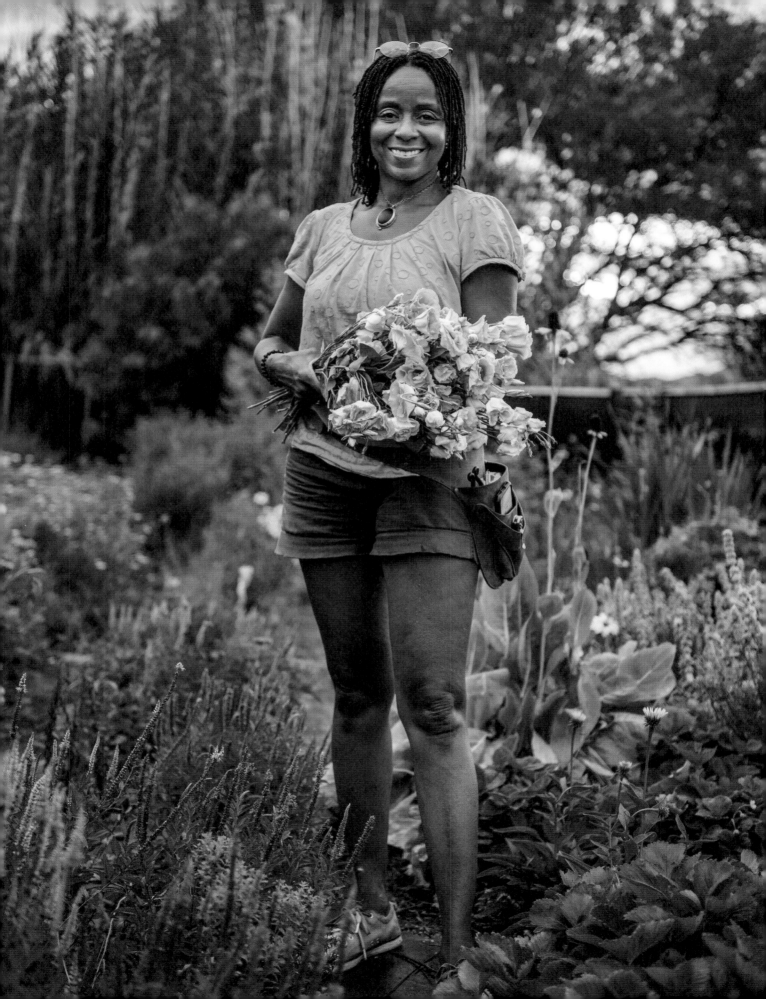

"One of the benefits about living here is that our ground never freezes and the soil is always workable."

With a large supermarket 25 miles away the community's only other source of flowers, Aishah's just-picked blooms tapped an unmet demand. Today, Patagonia Flower Farm supplies small natural food stores and CSA subscribers as far away as Tucson.

Aishah processes and designs flowers beneath a 9-by-20-foot shade house designed by Sebastian to withstand 70-mile-an-hour winds. He fashioned the sturdy, desert-suitable structure out of scrap cedar salvaged from the wooden flute manufacturer where he works, situating it in the heart of Aishah's flower fields.

In the fall, after sunflowers and lisianthus finish blooming, Aishah designs harvest-themed centerpieces and holiday arrangements made of local greenery. By early spring, she wows customers with flowering bulbs raised hydroponically in the walk-in cooler. Locals who have never before experienced Arizona-grown tulips and daffodils, complete with bulb and root, go crazy over them.

"People here are just so happy to buy something locally-grown that also supports a local business," Aishah says. "To know that I'm somebody up the street, here in the desert, and that I grow their flowers is really special."

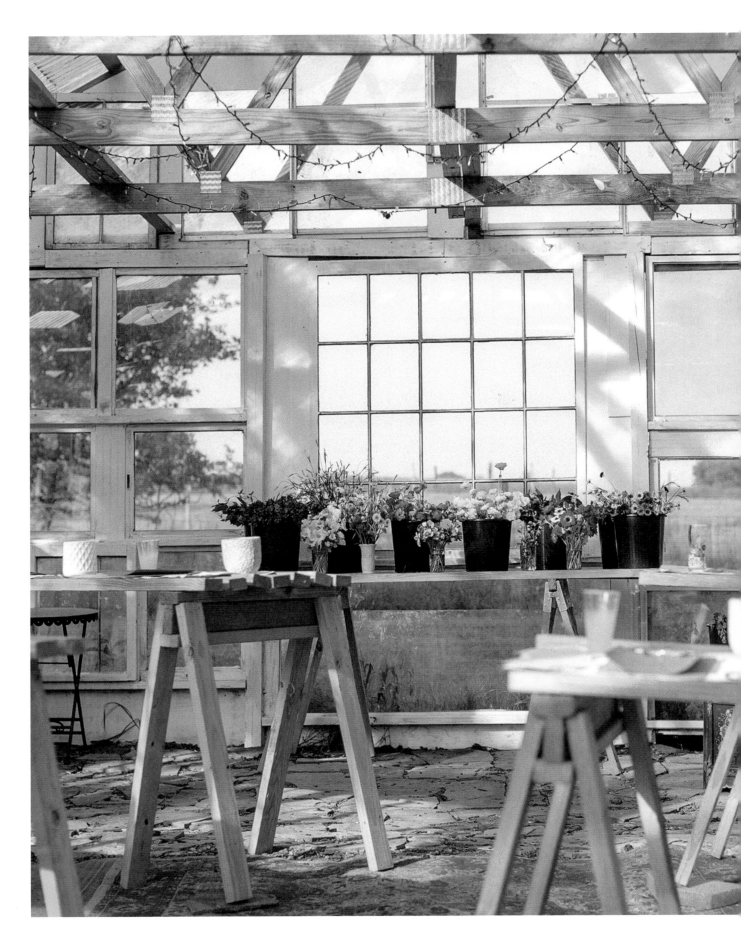

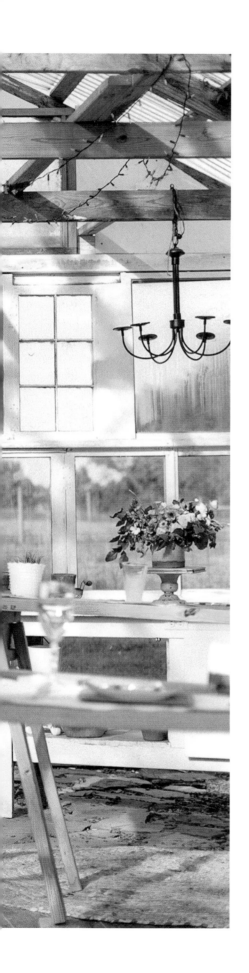

sun-catcher

WHERE FLOWERS GROW AND HUMAN CONNECTIONS ARE MADE

Jessica Broyles, Starry Fields Farm

Bowling Green, Kentucky

starryfieldsflowers.com, @jessica_starryfieldsfarm

Emily Rose Photography

At Starry Fields Farm, a 20-acre farm located 12 miles outside Bowling Green, Kentucky, Jessica and Ryan Broyles grow cut flowers, parent three children who love playing in the woods here, and raise chickens, ducks, pastured pigs, wool sheep, and the family dog.

Jessica has expanded Starry Fields beyond the original farmers' market stall into a floral enterprise that supplies custom seasonal bouquets for local delivery and weekly subscriptions, April through September.

In 2019, Ryan built a 768-square-foot greenhouse using 140 salvaged and reclaimed windows. This charming "room with a view" is nestled comfortably between two stately shade trees overlooking the nearby two-third-acre flower fields. Inside, open rafters are both functional and decorative, supporting a double-wall polycarbonate roof. Sawhorse worktables, also built by Ryan, can be rearranged for classes, or moved outside for events.

"You can buy flowers anywhere, but to experience them is different."

Jessica credits a photographer friend for suggesting both the site of the greenhouse and encouraging her to choose a distinctive architectural design. "We were talking about a hoop house or a barn, and then my friend said, 'Everyone has barns, so what else can you do?'" After seeing a Pinterest gallery of a home with a floor-to-ceiling wall of vintage windows, Jessica and Ryan imagined a glass structure of their own and began planning. "We started collecting lots of windows," she laughs. "Ryan consulted with an architect friend who helped us figure out how to make it as structurally safe as a traditional pole barn."

Jessica intended for the greenhouse to shelter her tender flower seedlings and store gardening tools. But she soon realized it was ideal for floral design workshops. "I used to have to lug everything everywhere I taught," she explains. "It's so much nicer to hold workshops here. We always begin each workshop with a field tour. Then we head back into the greenhouse, where tools, flowers and greenery, and refreshments are waiting for students. People like coming to Starry Fields. You can buy flowers anywhere, but to experience them is different."

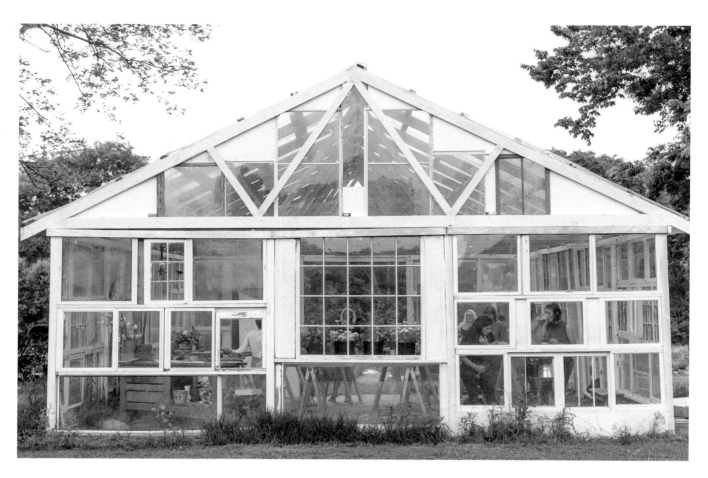

As more visitors saw the charming greenhouse, word spread. Local photographers asked to use it as a backdrop for engagement portraits and family photography, which led to requests to host small weddings and elopements at the farm. Regardless of the weather, the greenhouse has proven to be a magical destination that delights those who see it.

"There is so much great lighting inside," Jessica says. "Any time of the day – it's really amazing at sunrise; it's amazing at sunset. If it's overcast outdoors, the inside is still flooded with light. I love seeing all the flower colors pop when I bring them inside. It always inspires me."

Jessica loves being able to step away from her busy life as a mom and farmer-florist to spend time designing inside her greenhouse. "It's just very peaceful and calm, which is what we all need right now."

Joking that she and Ryan have more ideas than time, they are already scheming their next farm feature. "We want to give our Bowling Green community a unique experience that's different than anything else. Part of our property makes a natural amphitheater, so now we're planning to add a concert venue." They are working with a local university's architecture department to design an outdoor stage, while connecting with bands and acts.

"My tagline is 'growing flowers, connecting humans,'" Jessica shares. "This flower farm facilitates bringing people together, and we feel so blessed with this 20-acre place where that can happen."

"This flower farm facilitates bringing people together, and we feel so blessed with this 20-acre place where that can happen."

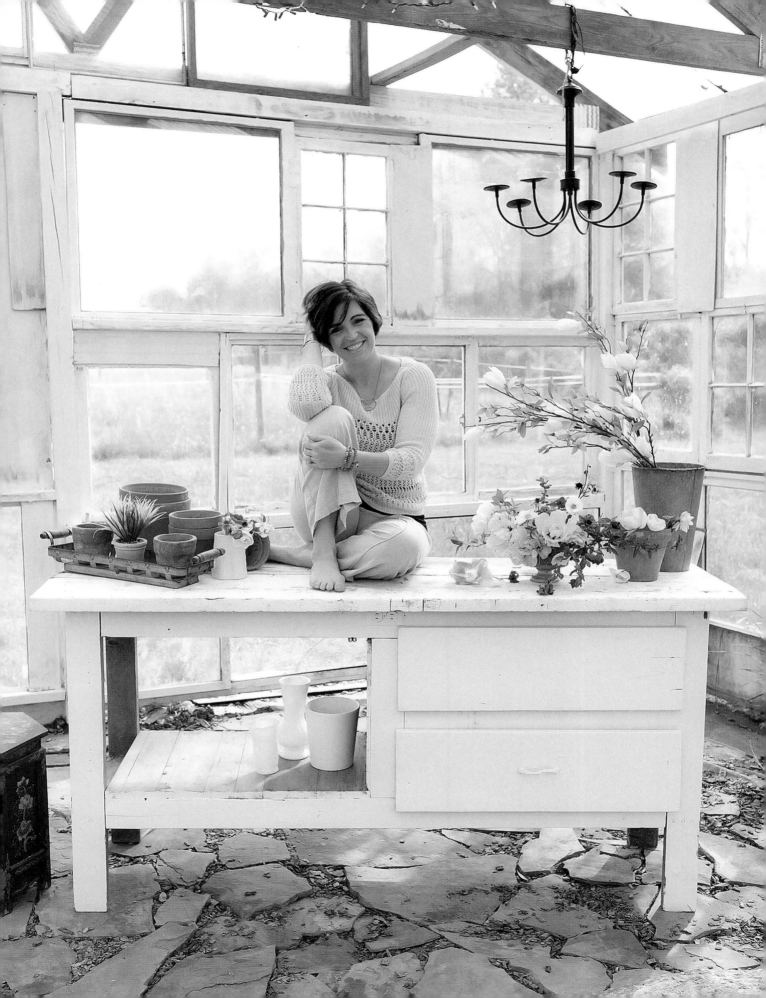

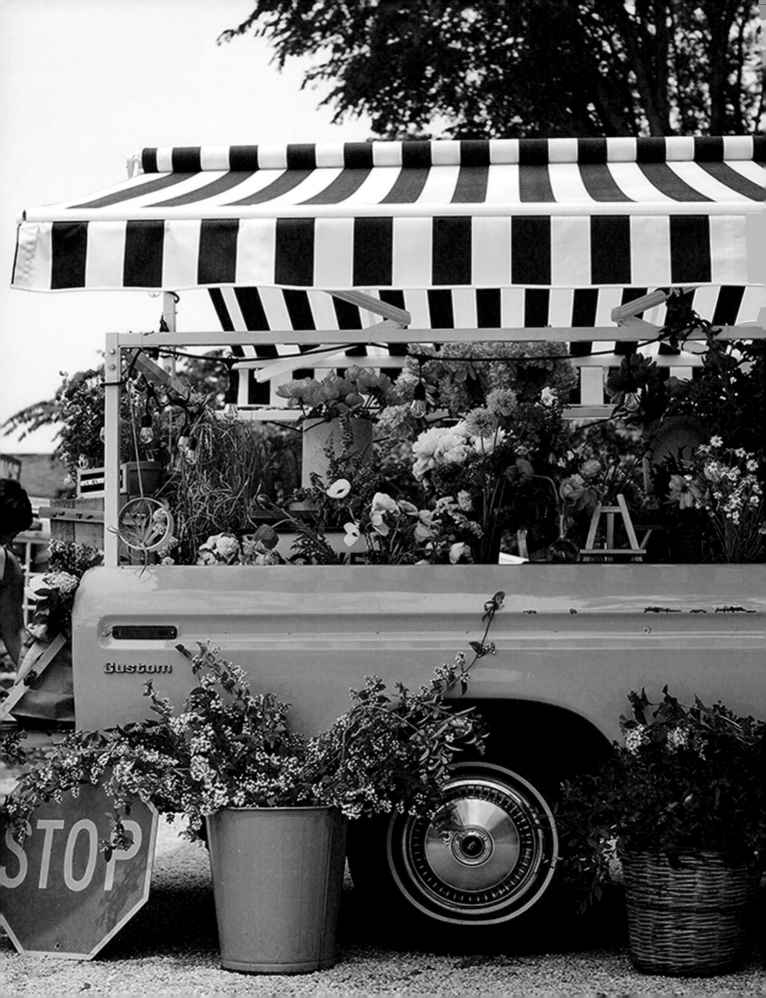

close to home

A MOBILE AND ALL-LOCAL FLOWER SHOP

Jaclyn Rutigliano and Marc Iervolino,
Hometown Flower Co.

Huntington, New York

hometownflowerco.com,
@hometownflowerco

Erica Schroeder Photography

"It's important for people to have an experience that connects them to their flowers, so they understand why we're doing this."

Jaclyn Rutigliano and her husband Marc Iervolino launched Hometown Flower Co. over Mother's Day weekend in 2019. Their "hometown" is Huntington, on New York's Long Island. "We are a fully-mobile and digital florist that sources exclusively from a collective of local flower growers," Jaclyn explains. "We abide by one rule, which is sourcing only in our 'backyard' — with what is seasonally available." Before launching, the couple spent a full season visiting Long Island flower farms to establish connections. Today, they procure from close to ten local growers.

Hometown Flower Co. is based in a vintage 1976 Ford pickup transformed into a flower stand with a playful black-and-white striped awning. People can't help but engage with the "buy local" message when "Baby Blue" shows up at farmers' markets, delivers CSA-style flower subscriptions (called "Flowers in a Bag"), or appears at private events. Some hosts schedule a flower crown workshop, others want a "flower bar" for guests to build their own bouquets. All interactions are designed to immerse people in flowers.

"I think the core differentiator for us, besides the local message, is the interactivity," Jaclyn says. "We are showcasing flowers that look kind of familiar but are a little different, and certainly not something that you would get from a traditional florist. It's important for people to have an experience connecting them to their flowers, so they understand why we're doing this. And maybe they walk away valuing flowers more."

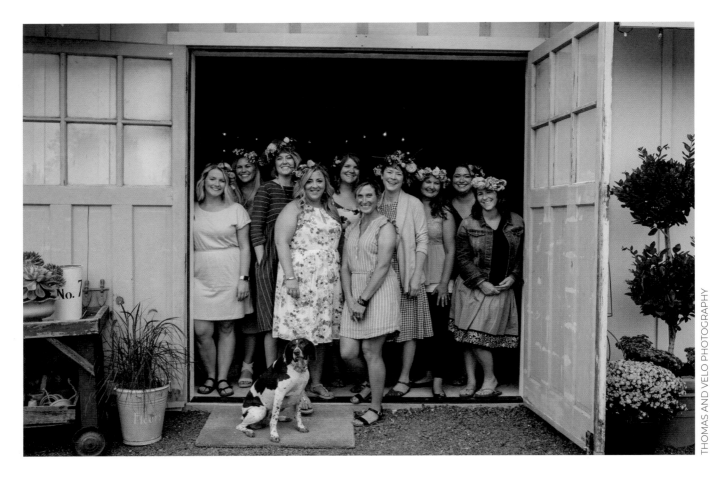

THOMAS AND VELO PHOTOGRAPHY

where local is beautiful

HEIRLOOM FLOWERS, GROWN AND DESIGNED IN CENTRAL OREGON

Jennifer Ladd, Sweet Posy Floral

Bend, Oregon

sweetposyfloral.com, @sweetposyfloral

"I love hearing other florists say: 'You always have those lovely bits that are going to elevate my designs.'"

Jen Ladd saw a barn's potential and re-imagined it as a cozy cottage for processing the flowers she grows at Sweet Posy Floral, her micro-farm in Bend, Oregon. Once occupied by horses and goats, the 1,000-square-foot structure is now part workshop-part studio. Double barn doors open to views of a two-acre wildflower meadow, pine trees, and the big Central Oregon sky.

While Jen came to flower farming after five years as a public-school literacy teacher, she has had her hands in the soil for decades. She often picked up summer-season work at local nurseries and landscaping firms, so when school district budget cuts eliminated her position, Jen was already on her way to a new vocation: Flower farming.

Jen and her husband Brandon, a firefighter, established Sweet Posy Floral on their five-acre parcel of land in 2015. "We began with flower subscriptions, which coincided with my first season designing for weddings," Jen says. "I started like many people, working in my kitchen and dining room and overflowing into the living room when I had big weddings."

As a tourism and vacation hub, Bend's lineup of ranches, wineries, and resorts place Sweet Posy Floral in an ideal position to serve couples

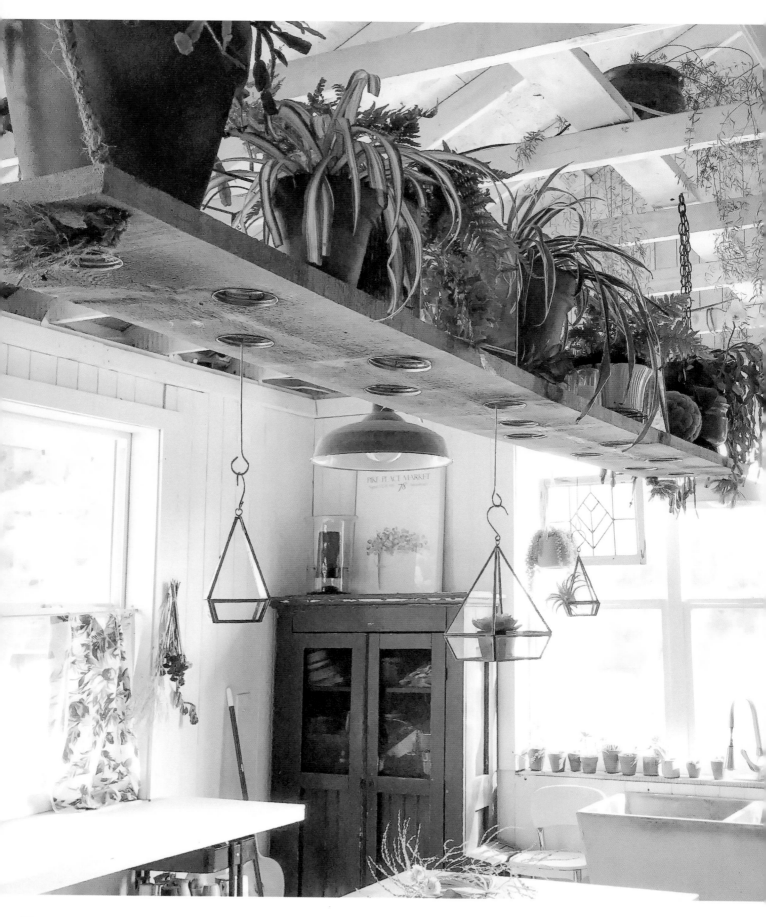

SWEET POSY FLORAL PHOTOGRAPHY

THOMAS AND VELO PHOTOGRAPHY (At top, center, bottom)

interested in local, Oregon-grown flowers. "We are destination central here," she jokes.

Sweet Posy Floral's tagline "Bend's original flower subscription," celebrates seasonal hand-tied bouquets. In spring, the bouquets contain French tulips, ranunculus, anemones, heirloom-scented sweet peas, and Icelandic poppies. Later, Jen's summer bouquets are filled with dahlias, anemones, sunflowers, sweet peas, snapdragons, and garden roses.

Jen also supplies other florists in the area, opening her cooler every Wednesday morning for as many as a half-dozen wholesale shoppers. "I love hearing other florists say, 'You always have those lovely bits that are going to elevate my designs,'" she confides.

The studio space emerged from a natural disaster. After their second growing season, a brutal winter storm dumped so much snowfall on Bend that the barn's shed-style roof collapsed. Inside, more than 30,000 dahlia tubers stored in crates quickly froze and rotted.

"I love when I can go into the field and pick the quirky flower stems with the curves and personality."

Good homeowners' insurance saved the day, allowing Jen to design and install a new standing-seam metal roof, complete with a dormer over the entry. Other upgrades came from salvaged architectural finds — doors, windows, siding — things that "represent our area," she says. She found the deep, double farm-sink online, convincing her male relatives to drag it home from Portland. An overhead plant rack, originally built by Brandon for hanging flowers and tea lights at outdoor weddings, has migrated to its current space above the worktable. Jen holds consultations in a seating area with a velvet-upholstered antique love seat and a chandelier made from dried amaranth. A pellet stove provides heat when temperatures drop.

"This has become my inspirational space, but it also welcomes and hosts many workshop experiences, weddings, bridal soirees, birthday parties, and we rent it out to book groups, garden clubs, and local businesses for their meetings," Jen explains. "We also rent to freelance designers and lifestyle photographers who use our farm and the studio for mini-sessions."

Last summer, Jen and Brandon converted an old wagon bed, complete with a buggy seat, into a roadside "Posy Cart" placed at the end of their driveway. Regular customers shop for flowers there all season on the honor system.

Each arrangement is unique and filled with character, which keeps regulars coming back for more. "I love when I can go in the field and pick the quirky flower stems with the curves and personality," Jen admits. "I get nerdy about designing with them."

island-grown blooms

THREE GENERATIONS OF FLOWER-LOVERS PUT DOWN ROOTS IN A WHIDBEY ISLAND FARMING COMMUNITY

Kim Gruetter + Tonneli Gruetter
Salty Acres Farm

Coupeville, Washington

saltyacresfarm.com, @salty_acres

Tonneli Gruetter Photography

"'Salty' is the perfect vehicle for every type of event!"

Tonneli Gruetter grew up in Oregon with farming parents, Kim and Paul Gruetter. Now, she has come full circle, growing dahlias, sweet peas, and edible flowers at Salty Acres Farm, working alongside her artist-husband John Loughman, their five-year-old son Sauvie, and yes, her parents.

John's Navy posting brought the couple to Oak Harbor, Washington, on Whidbey Island, in 2015. Tonneli and John didn't plan to be farmers, but then, the opportunity of a lifetime appeared: A charming farmhouse, historic barn, and plenty of land with views of Penn Cove. It didn't take much for Tonneli to convince her parents to join them.

Early on, their flower and produce display was a vintage pony cart-turned-flower stand. Kim and Tonneli realized how hard it was for one person to load and unload the cart each week. In search of an alternative, Tonneli noticed a Craigslist ad for a retired Japanese fire truck. "We turned the fire truck into our mobile flower shop or sidewalk flower stand. We literally roll up the sides to display racks of flowers," she says.

The quirky personalities of Salty Acres Farm's owners come through when they arrive behind the wheel of "Salty." "Hosts invite us to wow their guests with market bouquets, floral confetti, and sea salt party favors. 'Salty' is the perfect vehicle for every type of event!"

house & flower

AN INTERIOR DESIGNER DREAMS UP SPACES FILLED WITH FLOWERS + GARDENS

Cynthia Zamaria

Toronto, Ontario

cynthiazamaria.com, @cynthiazamaria

Robin Stubbert Photography

Cynthia Zamaria is a flower grower, gardener, interior designer, and editorial photography stylist who infuses her botanical aesthetic into everything she touches.

"My north star is a belief that creating beauty can manifest itself in a number of different ways," she says. "For me, it's always about a combination of interiors and flowers."

She once called herself a "recreational decorator," back when in the corporate world in communications, marketing, and public relations. In her spare time, craving an artistic outlet, Cynthia loved translating her visions into well-appointed rooms, both indoors and outdoors and this brought such joy that she was motivated to seek a new lifestyle. "I did the thing a lot of people do. I left my job because I wanted to do something more fulfilling. I wanted to create spaces and design with flowers, but not in a traditional way."

After attending flower farming workshops, joining online floristry communities and reading all she could, Cynthia was emboldened to follow her dream to plant, grow, and sell cut flowers as a business. She and her husband Graham Loughton weren't entirely beginners at growing; Cynthia's mother emigrated to Canada from Croatia, bringing with her "tried and true, practical old country farming techniques," which she instilled in her daughter. Graham's father emigrated from England to work at a Canadian agricultural research station and run vegetable growing trials.

"Creating beauty can manifest itself in a number of different ways. For me, it's always about a combination of interiors and flowers."

So, when they stumbled upon a forgotten historic home with garden potential, outside of Toronto in the small lakeside community of Port Dover, a place that just happened to be the same town where Graham attended high school, the possibilities were enticing.

"I wanted to take all the Slow Flowers principles and techniques I'd learned and bring intensive growing to our new garden," Cynthia explains, laughing over the reactions of neighbors, out on their walk in an area more residential than agricultural. "People stopped us all the time and asked us what we're doing because they had never really seen gardening done this way. We were bringing farming techniques to our front yard I remember saying, 'just wait — and in another month, this is going to be festooned.'"

Cynthia and Graham spent a year renovating and furnishing the interiors of their "heritage home" called Millar House, named after the family who built the home in 1857. They also transformed an original coach house into a garden studio and added a potting shed in the midst of a new field of flowers. "I think beauty is optimism," Cynthia maintains. "There is intrinsic potential in everything, and that's part of

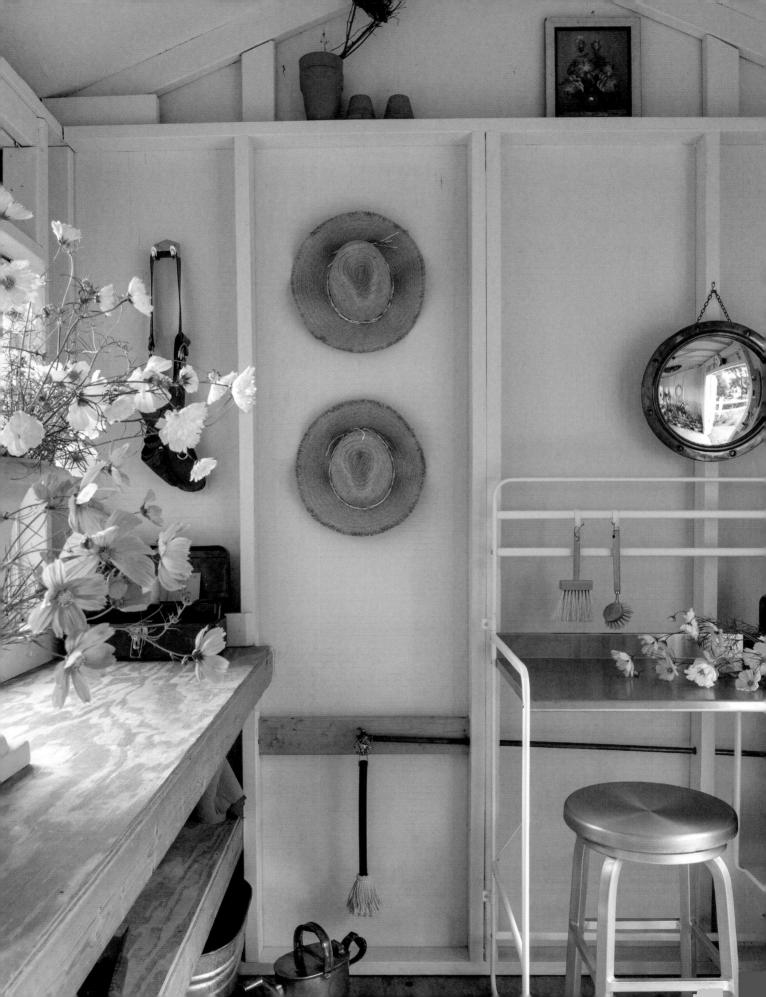

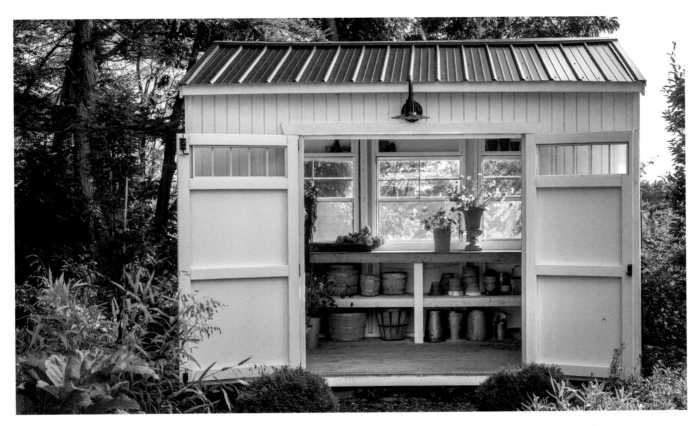

"For me, the environment is as equally important as what I create.
It's an act of creation itself and always evolving."

the joyful challenge. It's almost more fun when the potential of a place is less obvious."

The potting shed is Cynthia's hub in so many ways. Measuring 9-by-12 feet, the wood structure was constructed off-site and delivered to just the right spot overlooking Silver Lake. That's where Cynthia's interior designer's eye for detail made magic happen.

To ensure she could design in a light-filled interior, Cynthia customized the finishing details: a bank of three windows overlooking the lake spans the outer wall; double-French doors expand into the garden. "I wanted the ability to open both of the doors, so I feel like I'm almost outside when I'm working in here. I wanted lots of counter and storage space, so I can process flowers and do some arranging. I have my tools just where I need them. We kept the floor plywood, so it's easy to brush up. But there are luxuries, too, such as having water installed — there is a sink and a bucket-filler spigot, which is a nice treat not to have to lug water back and forth," she explains.

Cynthia's garden "headquarters" is essential to her aesthetic as a floral and interior designer, she says. "For me, the environment I work in is as important as what I create. I need order and it needs to be pretty. Plus, it's an act of creation itself and always evolving."

"Sometimes on the way to your dream, you get lost and find a better one."

Nice music is playing, there's a steaming mug of coffee, and Cynthia is surrounded with her favorite collections and flowers. "It's evocative of a mood or a season, and always changing!"

Speaking of changes, Cynthia's original plan to farm flowers on a large scale has morphed into a career growing flowers for photo shoots and styling projects, many of which are published in Cynthia's blog and publications such as Domino, Apartment Therapy, HGTV, Good Housekeeping, Woman's Day, Country Living Style at Home, and House and Home.

"At one point, I was going to be a flower farmer and host workshops and sell flowers to the market," she says. "But sometimes on the way to your dream, you get lost and you find a better one. It's very fulfilling to share our flower garden with other people so they too can be inspired to create more beauty in their lives."

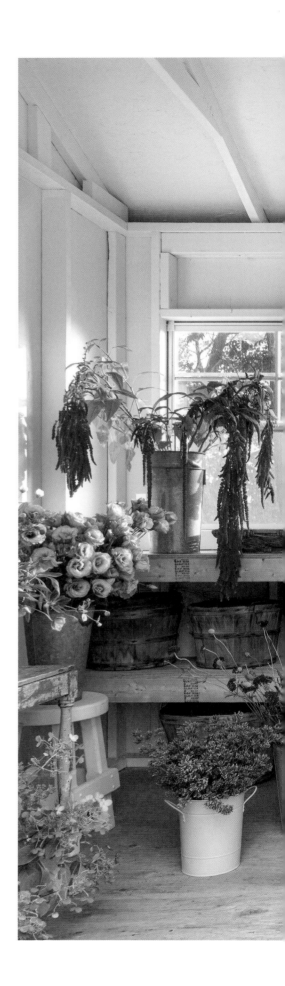

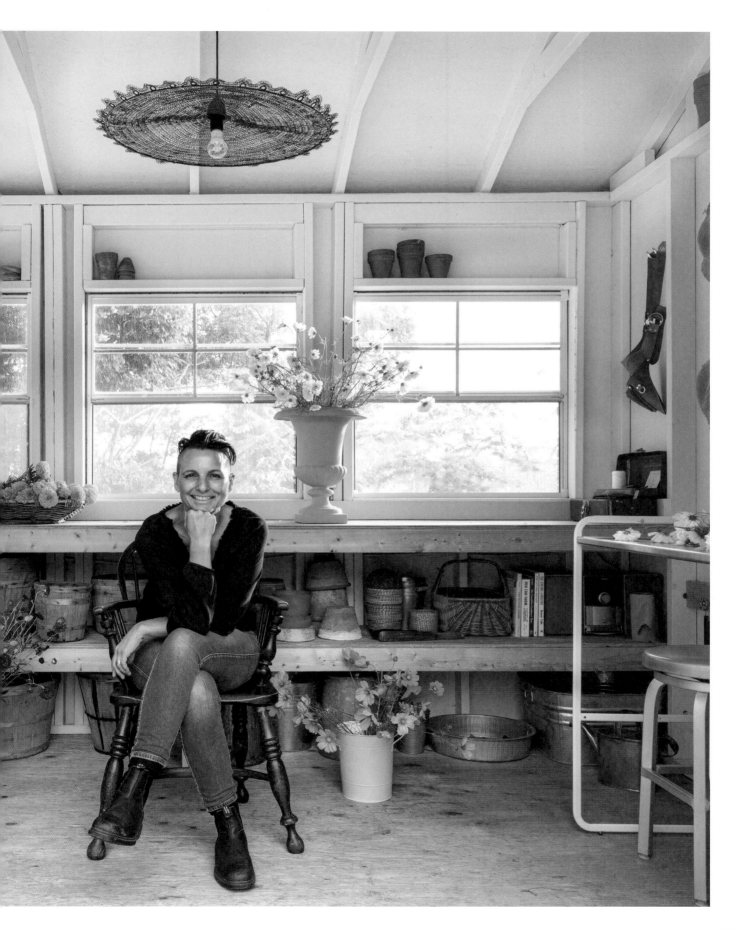

under the oaks

IN HER CARPORT-TURNED-WORKSHOP, A DESIGNER
DRAWS INSPIRATION FROM CALIFORNIA'S FLORA

Jane Hand, Jane's Workshop, Carmel Valley, California

@janes_workshop_831

Laura Cohen Photography

Jane Hand spent more than two decades developing and marketing specialty foods, helping growers translate their harvests into value-added brands. She's now applying the skills she once used in the culinary marketplace to operate her floral studio called Jane's Workshop.

Serving private clients and small fundraising events, Jane's Workshop creates custom seasonal floral arrangements for the Carmel Valley community, located about 13 miles inland from the Central California coast. Jane's property is shaded by live oaks and other mature trees, which hampers her efforts to grow sun-loving flowers like dahlias. But she has embraced the hydrangeas, ferns, and vines that thrive here, while also developing relationships with local growers, gardeners, and arborists who are her suppliers.

In 2017, as she became more serious about floral design, Jane considered finding a studio in her village. "We had a carport and I thought, 'why pay money to rent a place when I can make what I need right here?'" she says. "I enclosed it with salvaged lumber, windows, and two sets of French doors."

"I like working outside, but I love being inside my workshop looking out."

What was once just a roof and four posts is now a verdant floral hub. It's clad in passion vine with periwinkle flowers that reflect French blue fascia boards and twin doors.

As she began to accept more floral commissions for auctions, galas, and other cultural events, Jane thought she needed a couple of acres to grow more flowers. "Because if you don't grow unusual ingredients, where do you source them?" she wondered.

Enter Jane's friend and now-frequent collaborator Laura Cohen of The Posy Express (see page 96). As Laura's Carmel Valley micro flower farm expanded, and as Jane yearned for uncommon seasonal blooms, the women formed a creative partnership. Jane's shady garden became her design studio, and she relies on a wide array of blooms from Laura's sunnier fields nearby.

Jane can be found outdoors, designing on oak barrels, or in the workshop at her rustic bench fashioned from a stack of concrete blocks and a slab of wood. "I like working outside, but I love being inside my workshop looking out," Jane says.

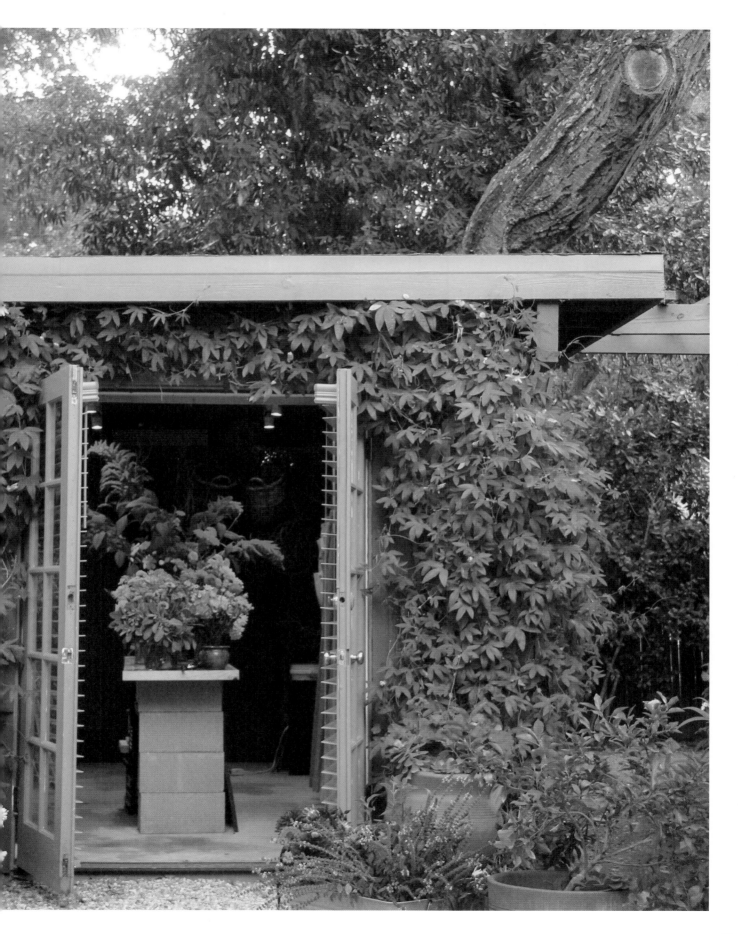

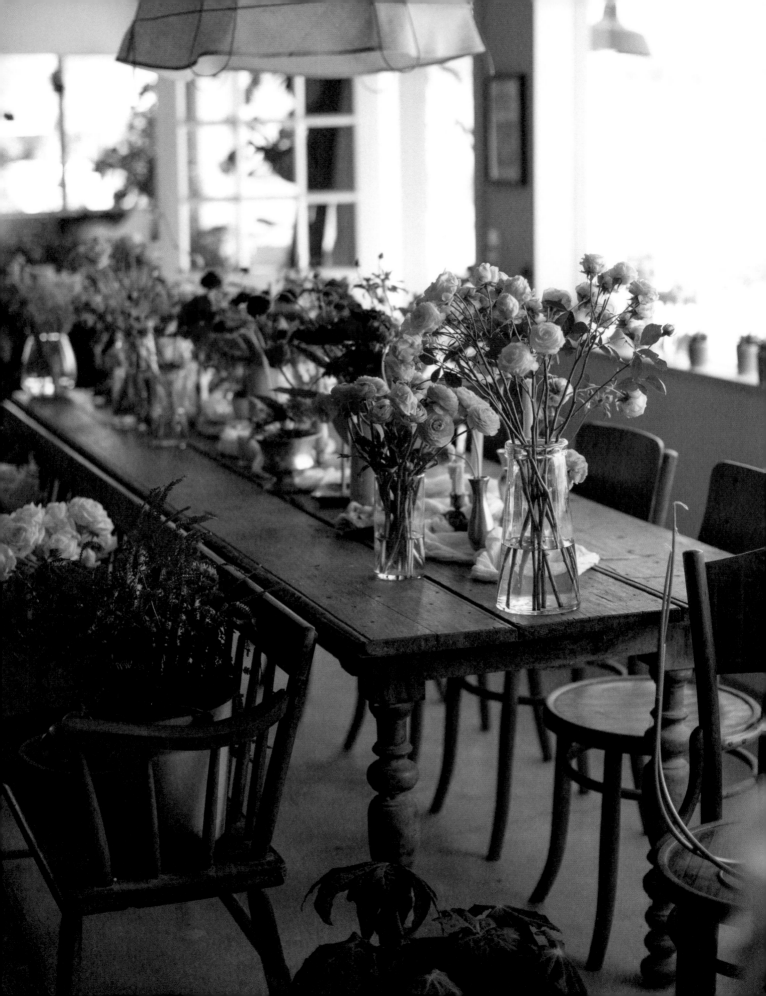

inspired by nature

A FLORAL DESIGNER TRANSFORMS A 1960s ELECTRICIAN'S SHOP INTO AN ATELIER FOR SUSTAINABLE FLOWERS AND DECOR

Jill Redman, Forage Florals

Santa Ynez, California

forageflorals.com, @forageflorals

Elizabeth Messina Photography

After a number of creative endeavors, including interior space planning and design, metal-smith work, and jewelry fabrication, Jill Redman claims that "flowers found me." Similarly, after five years as a studio florist, an empty retail shop unexpectedly "found" Jill, presenting her a new creative chapter for Forage Florals.

Previously, Jill operated as the in-house florist at a local winery, focusing on events and wedding florals for Santa Ynez Valley and Santa Barbara area clients.

She developed Forage Florals' garden-inspired aesthetic, sourcing flowers from nearby growers and wild-foraging from what grew at her family residence.

As her local customer base expanded, Jill recognized the limitations of running an appointment-only studio behind the winery's locked gates. "I needed to be a little more present and move in a new direction, but I never thought I would have a store," she confides.

"No two arrangements are alike, and availability of blooms is directly up to Mother Nature and the current season."

In August 2019, she headed home from the winery and drove through the one-street retail district of Santa Ynez. "I turned left instead of right and found this gorgeous, empty space with high ceilings. It fell into my lap the same way floristry did," Jill says.

She tracked down the landlord, and by November, opened Forage Florals as a retail flower shop, just five weeks after signing the lease. "I went from having a very relaxed wedding business to running a full-on retail business," she laughs. "I don't always weigh options when I say 'yes.' But then I have to figure it out."

Jill describes Forage Florals as a full-service floral and lifestyle retailer. The shop supports "makers," including Jill's husband, a ceramic artist, and local jewelers and craftspersons. Jill and florist Laura Cogan, who works for Forage Florals, are themselves makers of plant-dyed silk ribbon. "Every day, no matter what botanical material we bring in, we put some of it in a pot and see what happens with our ribbons," Jill explains. "Nothing ever comes out the same, but it's pretty magical. We tie all the bouquets going out the door with our custom-dyed silks."

The 40-by-40-foot building was a blank canvas for Jill's artistry. Her interior designer's eye served her well as she transformed the industrial space with Amish furniture and other antiques. A vintage French apothecary vitrine displays ribbons, and a distressed cabinet stands at the cash-wrap, its canvas doors hand-painted with oversized roses by Jill. Overhead, exposed beams and rafters support strands of cafe lights and pendants.

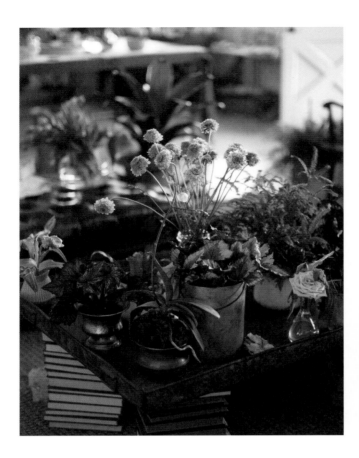
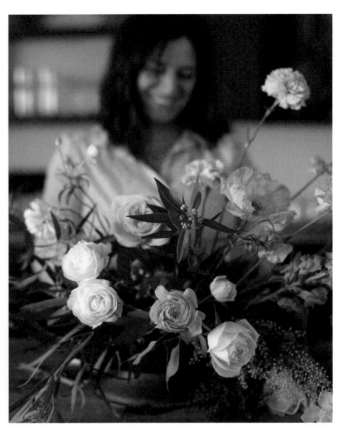

"I want you to feel something when you walk into my store, something emotional or sensory. If something here triggers a sensation for you, I know you'll come back."

The storefront looks out onto a pasture of "little black cows, rolling hills, and live oak trees," Jill says. "It's my favorite place now. I love it so much." In the back of the shop, a 10-by-14-foot garage door is often rolled back to expand outdoors. Once a parking lot, it has been converted into a courtyard where open-air workshops take place.

Forage Florals' website declares its commitment to a Slow Flowers' ethos: "We proudly source local blooms and foliage from farms within a five-mile radius. Design and artistry are at the forefront of all custom arrangements. No two arrangements are alike, and availability of blooms is directly up to Mother Nature and the current season."

"This practice is possible because of several boutique flower farms in the vicinity, including sources of local roses and dahlias," Jill explains.

Jill's customers are invited to peruse buckets of flowers and select their bouquet, stem-by-stem, much as you might find in a European flower shop. "I want you to feel something when you walk into my store, something emotional or sensory. If something here triggers a sensation for you, I know you'll come back."

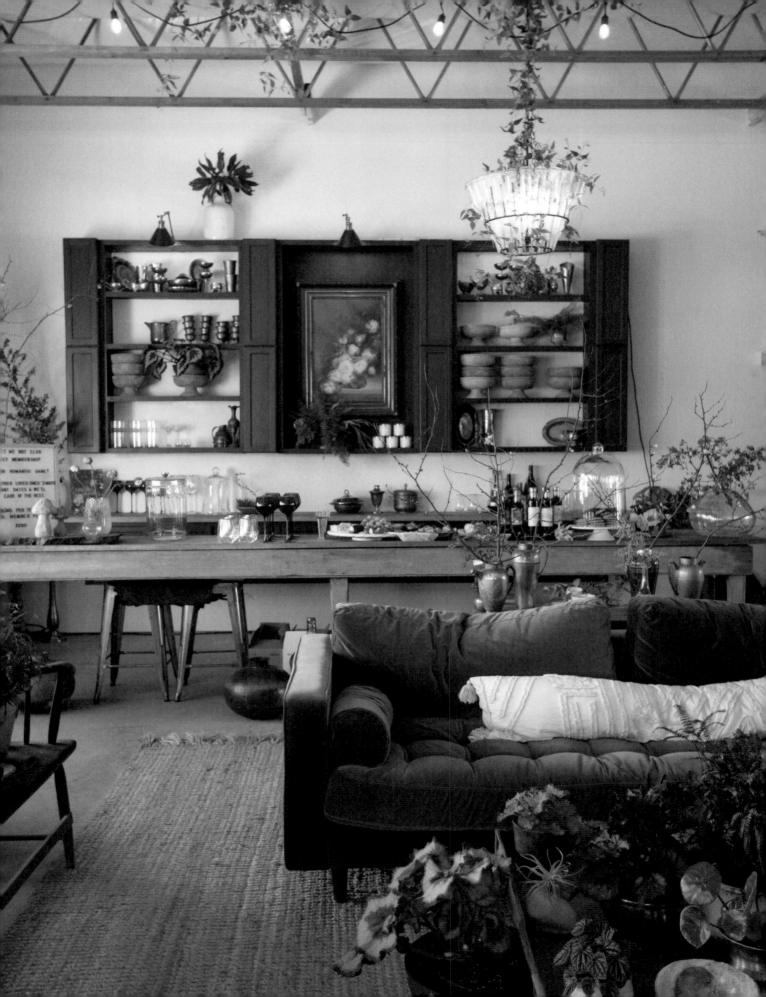

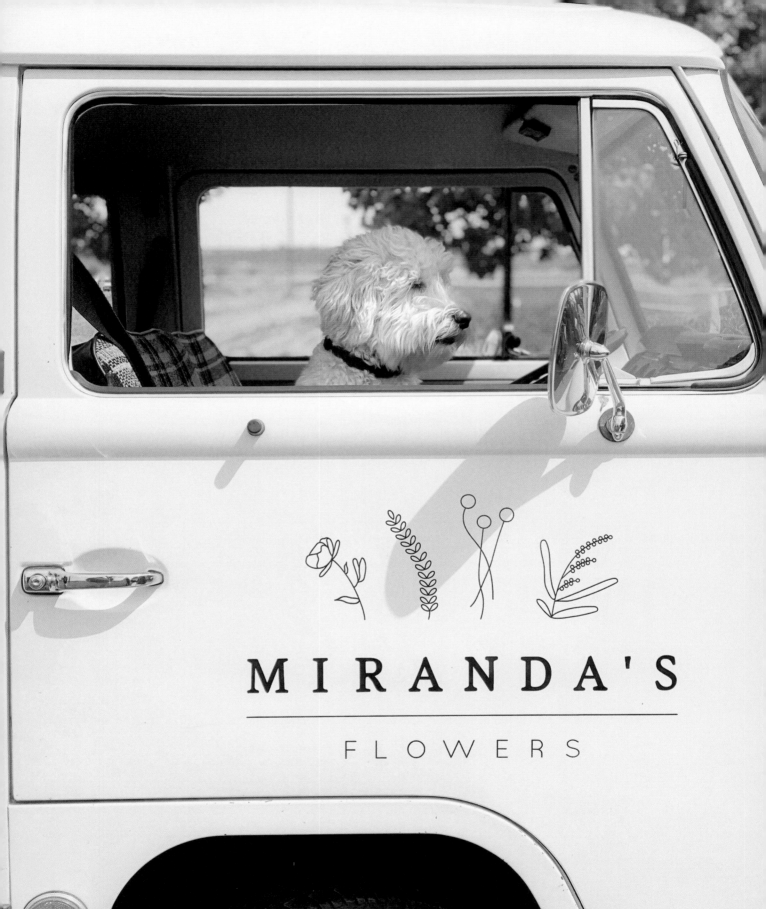

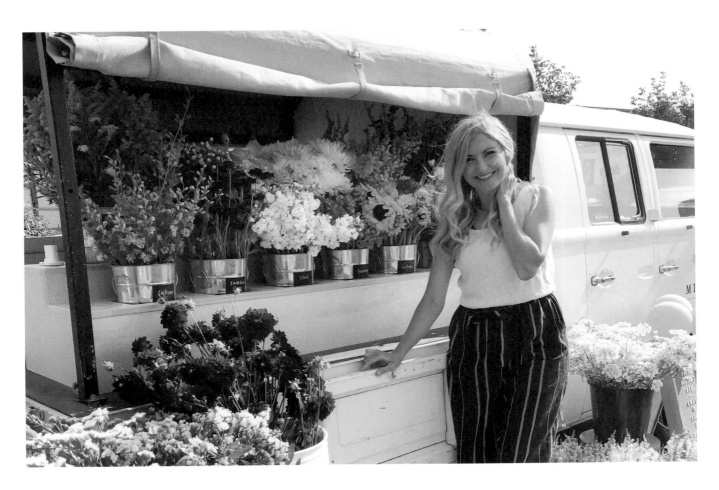

road trippin'

**A 1960s VW TRUCK, RE-IMAGINED
AS A MOBILE FLOWER SHOP**

Miranda Edwards, Miranda's Flowers

Pasco, Washington

mirandasflowers.com,
@mirandasflowersco

Miranda Edwards Photography

"I was obsessed with the idea
that I could walk through a
field of flowers I had grown."

Graphic designer and illustrator Miranda Edwards was swept up by the romance of growing her own flowers after following other farmer-florists on Instagram. Her husband signed her up for an online flower farming course in 2018, and Miranda wholeheartedly embraced a new career.

Today, Miranda's Flowers is a boutique floral studio based on five acres in Pasco, a community in southeastern Washington, where the Lewis & Clark Expedition camped in 1805. Miranda, her husband, and their three children moved here in 2016. "I was obsessed with the idea that I could walk through a field of flowers I had grown," she says.

Miranda first offered Mason jars filled with cosmos, zinnias, and dahlias, vending from an adorable custom-build flower cart that her husband built. "I set up outside a local coffee shop on Saturdays," she says. "I sold about 20 jars each time, so I was encouraged." She scoured online sources, finding a vintage 1968 VW truck with a canvas canopy over the bed. With a nod to the VW's German roots, Miranda named her new flower truck 'Frieda.'

Miranda illustrated her botanical logo, and she considers the flower truck an extension of her visual branding. "My favorite moment is when someone discovers our flower truck and flowers. I feel like I've created an environment where people in my community can experience locally-grown flowers."

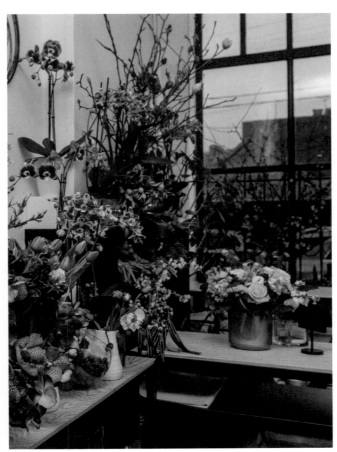

luxury goods

A FASHIONISTA OPENS A PETITE STOREFRONT FOR BESPOKE FLORAL DESIGN

Susan Chambers, bloominCouture

San Francisco, California

bloomincouture.com, @bloomincouture

Cherlyn Wagner Photography

"I wanted everything simple and utilitarian, to show off the color of my flowers and my designs."

Susan Chambers studied art and filmmaking before enjoying a career at Saks Fifth Avenue, I. Magnin & Co., and later for couture labels around the globe.

In 2013, after sending her youngest child off to school, Susan was drawn to floral design. "I was missing that breath of life through creating," she recalls. The pivot from fashion to floral design became Susan's self-described "Master's program." After a year of private courses, the designer traveled to London to study at the famed McQueens Flower School.

She named her studio bloominCouture, infusing the floral enterprise with an aesthetic and philosophy from her original career. Susan's first workshop was inside the subterranean garage behind her San Francisco residence, where she worked with the door open in order to have some natural light. "It was dark and cold – perfect for flowers, but not great for photography. I have to say, it looked hilarious for someone using the hashtag #luxuryflowers to be working in a dark garage."

Weddings represent a small portion of bloominCouture's clientele, complemented by her "whole home floral" service for San Francisco clients who appreciate how Susan's arrangements reflect their interiors and artwork, as well as holiday decor.

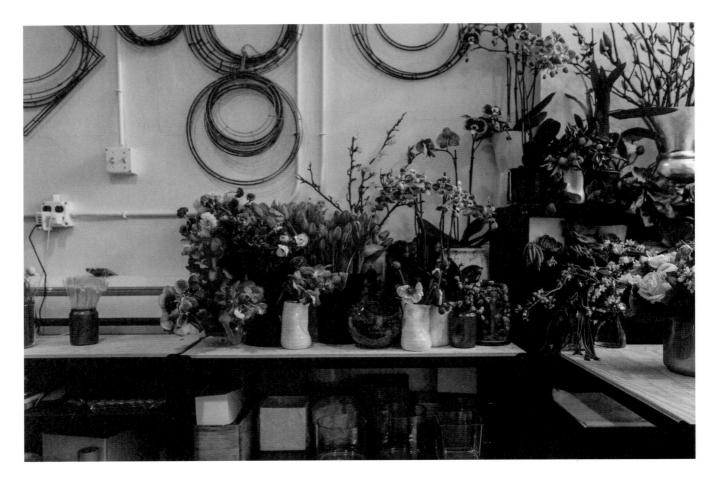

At the end of 2019, Susan learned a small storefront in San Francisco's tony Russian Hill neighborhood was vacant after housing an Italian shoemaker for 40 years. "We walked through the space in early 2020. It was painted dark blue gray — the ceiling, the walls — everything was so dark. But I was captivated by the 15-foot-high floor-to-ceiling windows welcoming in perfect north-facing light."

Just 10-feet wide and twice as deep, the shop is housed in a building more than a century old that survived San Francisco's historic 1906 earthquake and fires. Susan viewed the location as a once-in-a-lifetime brand-building opportunity. "It's quirky and funky, but it's also in the Russian Hill neighborhood. It's next to a Starbucks and a Peet's and the best candy store in the city."

She signed the lease on February 1, 2020, and during the weeks before Valentine's Day, Susan and her husband Jeff Moray painted every interior surface white or black, and waxed the century-old floor to highlight the weathered planks. "I wanted everything simple and utilitarian to show off the color of my flowers and my designs."

She intended to use the space to design and teach small workshops, not to open with regular retail hours. And yet, having a physical presence in Russian Hill is "my calling card," Susan says. "Many of my customer calls begin like this: 'I walked by your studio. Can I order flowers and have them delivered?' I have clearly found my niche in this city."

"I'm bridging the world of luxury floristry, my passion for sustainability and my relaxed California aesthetic."

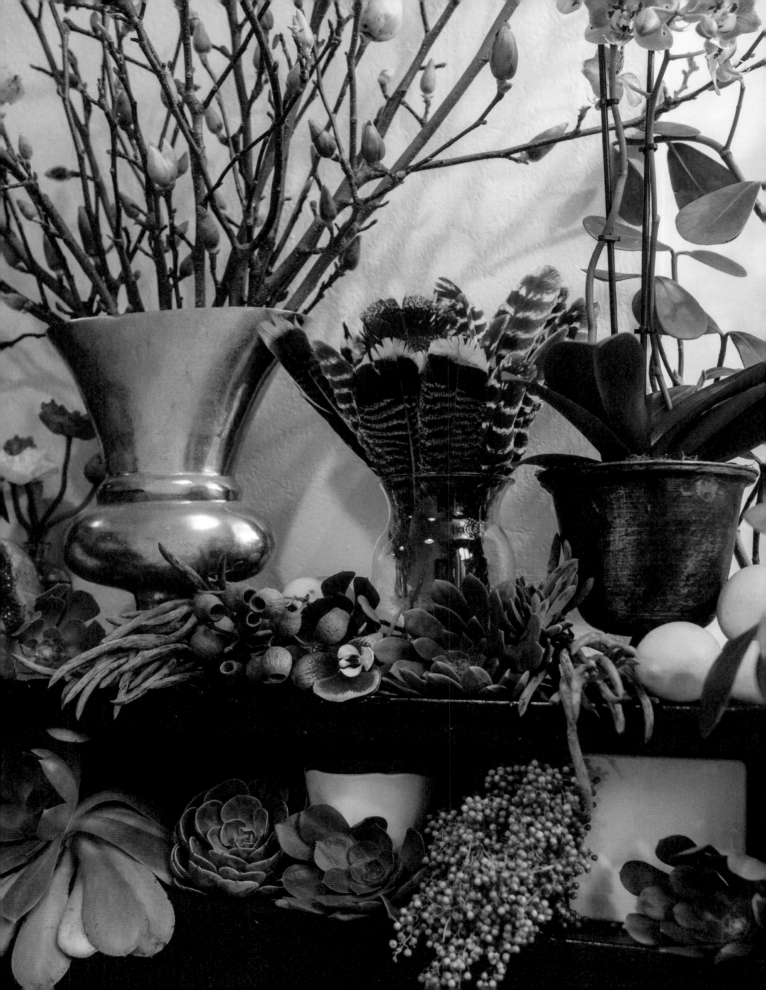

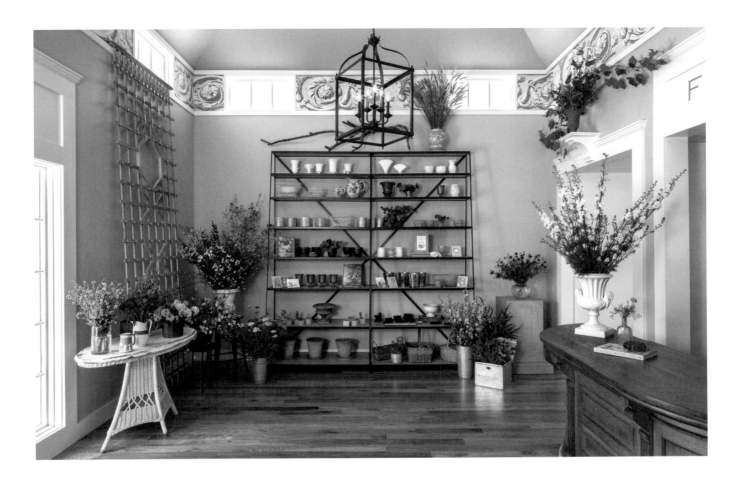

floral revival

AN ARCHITECTURAL PERIOD
PIECE INSPIRES A CHARMING
FLOWER SHOP

Jenny Elliott and Luke Franco,
Tiny Hearts Farm & Flower Shop

Hillsdale, New York

tinyheartsfarm.com, @tinyheartsfarm,
@tinyheartsflowershop

Art Gray Photography

"It elevates all the beautiful
flowers we're bringing out of
our field."

Jenny Elliott and Luke Franco, classically-trained musicians, parents of two little boys, and sustainable flower growers, operate Tiny Hearts Farm on 22 acres in New York's Hudson Valley. Established in 2011, they wholesale flowers to professional florists, design for wedding clients, and maintain a popular floral subscription program.

In 2018, they opened Tiny Hearts Flower Shop, crediting landlord Matthew White of WhiteWebb for convincing them to expand into retail. In designing the storefront, White modeled it after an historic Greek Revival building that once stood on the site. Tiny Hearts' fresh and seasonal blooms are now displayed beneath 16-foot-high ceilings bordered in trompe l'oeil. The vintage countertop is polished as brightly as the hardwood floors, while shelves and fixtures hold botanical merchandise. Jenny and Luke jokingly call their store a "glorified farm stand," but it is so much more. "It elevates all the beautiful flowers we're bringing out of our field," Luke says.

Jenny adds: "If you come to our farm for a consultation, you're pulling up next to our muddy pickup truck and tractor — and you had better be wearing muck boots. This gorgeous showroom has changed the perception of our flowers and our design services."

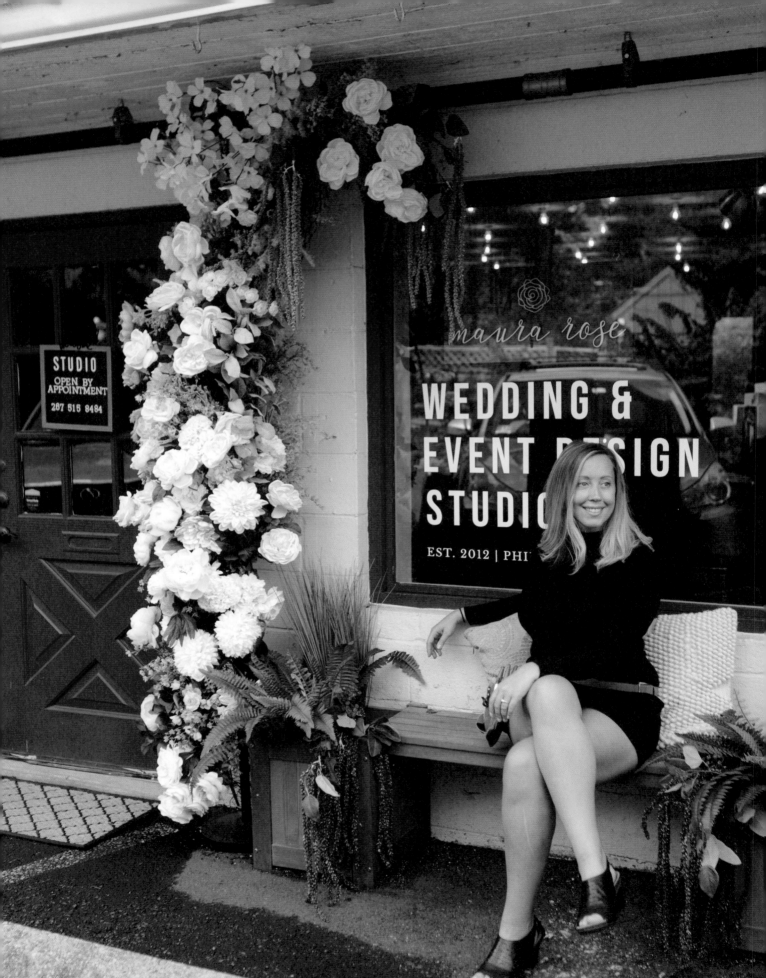

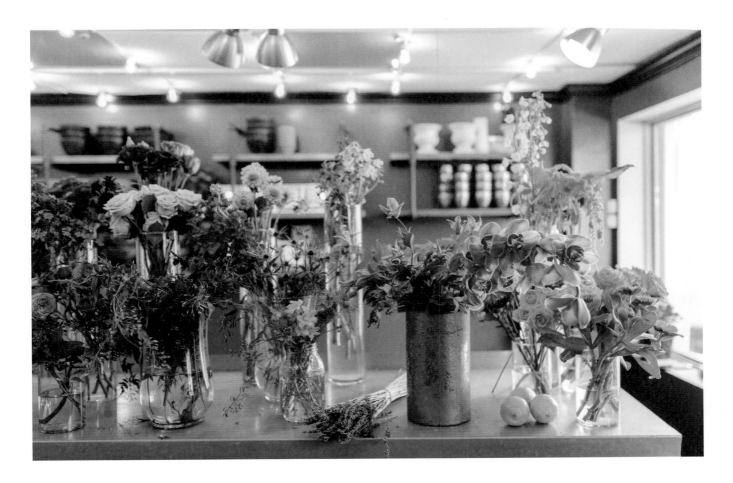

earth's beauty

A WEDDING FLORAL STUDIO FEELS BOTH RUSTIC AND MODERN

Maura Feeney, Camellia Faire

Yardley, Pennsylvania

camelliafaire.com, @camelliafairefloral

Janine Feeney Photography

"...create with the beauty the earth provides us."

Maura Feeney, owner and principal designer at Camellia Faire, serves wedding and event customers in the greater Philadelphia area and beyond. Flowers have infused her life since her first flower shop job at age 14. By the time she was 26, in 2012, she had launched Philadelphia-based Maura Rose Floral Design & Events.

In 2018, Maura brought her business back to Yardley Borough, the Bucks County township where she grew up. She moved the studio into a former hair salon, renovating the 1,200-square-foot space to accommodate custom stainless-steel worktables that can be rearranged for small workshops and for larger productions.

The affirming message, "Live a quiet life and work with your hands," hangs on a wood-clad accent wall, communicating Maura's values. Elsewhere a lettered sign reads "... create with the beauty the earth provides us."

A female mannequin covered in moss and named "Eve," is the studio's organic muse. Maura originally created the figure for one of her exhibitions at the Philadelphia Flower Show, where she is a frequently floral design winner. "We talk to her — she's our spirit guide," Maura laughs.

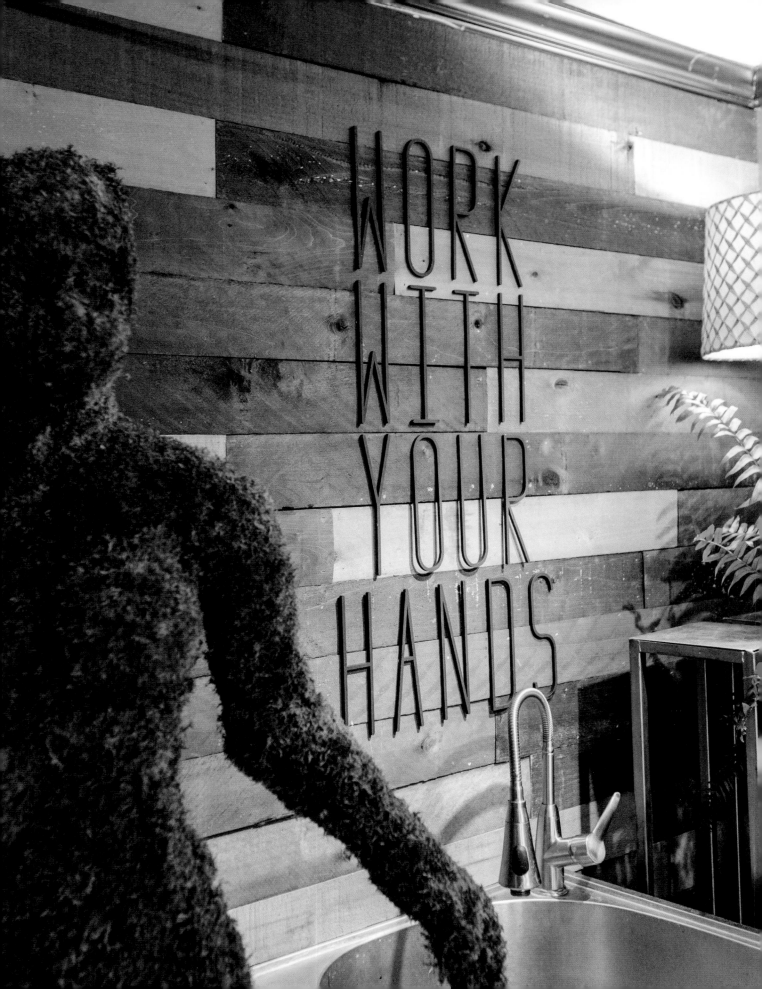

"We picked the dark wood tones and the dark gray walls, sort of making the space have an earthy vibe."

The moss and plenty of live plants play off the natural wood, industrial fixtures, and dark, glossy interior space. "A lot of flower studios have white walls and lots of natural light, but ours only has one big window," Maura says. "So, we thought, let's go for it. We picked the dark wood tones and the dark gray walls, sort of making the space have an earthy vibe."

Because the interiors are cozy, there are "cubbies" for storing tools, vases, and other supplies. "The one rule we have is to always leave the studio clean and organized so that we don't lose our sanity," Maura admits.

Working closely with Erin Bogart, her sister and key employee, Maura recently rebranded the business as Camellia Faire. "It was time to make the shift from being a one-woman company and to see how far we can grow this business," she explains. "We want to have an online shop, we want to do a little retail, and we have a little bit of land at my home to start our flower farm." There is no doubt Maura's connection to her hometown will deepen as she pursues fulfillment in her life immersed in flowers.

a botanical lifestyle

THEIR SWEET RETREAT IS HOME TO GROWING, DESIGNING, AND CREATIVITY

Karen Plarisan & Karly Sahr
Verbena Living

Roseville, California

verbenaliving.com, @verbena.living

Karly Sahr Photography

"This studio gives us the option to create whatever we want!"

Verbena Living is owned by a mother-daughter duo who lives and breathes flowers. They are also makers of one-of-a-kind pottery, charcuterie boards, and textile items for their popular Etsy shop. All of these artistic ventures spring from nature, inspired by Verbena Living's one-acre micro flower farm and inviting cottage studio in Roseville, California.

Daughter Karly Sahr has a graphic design and art degree from UC Davis, while mother Karen Plarisan has a landscape design and horticulture background. In 2008, Karen turned her gardening talents into a new floral enterprise. "I wanted to have a flower shop," she confides. The business name evolved into Verbena Living as Karen found her botanically inspired niche. Karly joined Verbena full-time after graduation, bringing her marketing and visual arts talents to the enterprise.

After a few years in retail, though, the women yearned for a more sustainable business model. "Our retail shop was 45 minutes away from home and we were wasting so much time driving," Karen explains. "We decided to transition to having a design studio and a working flower farm. By 2011, we planted our first test garden," she continues. "We love farming and we come from a florist background.

"It's such a gift and it's a relief to spend time with my flowers. Everything else disappears and my heart just feels better."

Growing our own flowers adds that extra element to our arrangements and bouquets."

In 2013, with lots of help from her brother and her husband Greg, Karly designed and built a studio on an existing concrete pad at Karen's property. "We turned what was basically a two-car garage into the perfect little home for our floral designs," Karly says. She and Greg live 20 minutes away where an "annex" cutting garden provides even more flowers for Verbena Living's designs.

Measuring 420-square-feet, the studio's bare-bones interior sufficed for many years, especially when the women were juggling too many wedding gigs.

But they saw its potential for photo shoots and small workshops, especially as Verbena Living scaled back its wedding bookings. In 2020, using Karly's experience as a woodworker, they remodeled the interior themselves. Light-filled with white and pale blue finishes, the upgrade has a welcoming "modern farmhouse" vibe.

Karly documented the renovation on Verbena Living's Instagram account, sharing the process of installing new IKEA cabinetry with custom bead-board doors and drawers from a company called Semihandmade. She showed how two 46-inch-wide white Husky tool benches from Home Depot became a spacious work island.

"We love doing, making, sewing, dying with nature and painting with watercolors.

With two huge picture windows on adjacent walls, natural light washes the interior. There is one corner devoted to Karly's pottery wheel and she says returning to the medium of clay was a natural way to complement the flowers she and her mother raise.

Truly, this pair of Renaissance women enjoy many artistic expressions. "We love doing, making, sewing, dying with nature, and painting with watercolors," Karly says. "This studio gives us the option to create whatever we want!"

Verbena Living now sells its harvest to other florists and books small weddings each season. There are also plans to build a farm stand at the front of the property where locals will find custom bouquets and hand-made pottery.

Karen cherishes her floral lifestyle, enhanced by beautiful blooms steps from her studio door. "It's such a gift and it's a relief to spend time with my flowers. Everything else disappears and my heart just feels better."

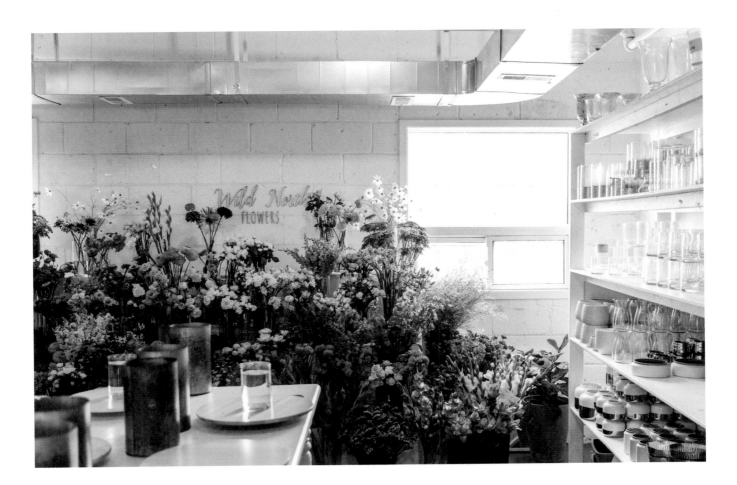

100% ontario-grown

A NEW MODEL PUTS FRESH, LOCAL FLOWERS INTO THE HANDS OF TORONTO CUSTOMERS

Jennifer Fowlow, Wild North Flowers

Toronto, Ontario

wildnorthflowers.com, @wildnorthflowers

Wild North Photography

"The fact that I get to see flowers every day is beyond a dream come true."

While in graduate school studying for a Ph.D. in feminist studies, Jennifer Fowlow daydreamed about flowers. "I've been obsessed with flowers my whole life, but I thought I was going to be a professor," she says. Her Instagram feed filled with bouquets and blooms. "The more I got into it, I sensed that academia wasn't for me."

At the start of 2015, Jennifer enrolled in a course at the Canadian Institute of Floral Design, asking colleagues to cover her lectures. "By the second day, I realized I wouldn't be finishing that Ph.D."

Later, while interning for Coriander Girl, a Toronto flower shop, Jennifer noticed how hard it was to order flowers online. "I spent four months on my couch, in my pajamas, researching everything. I realized Ontario has a massive floriculture industry — the third largest in North America — and I had this crazy idea to use all Ontario-grown flowers. Every single person in the industry told me that was insane."

She wasn't deterred, launching Wild North Flowers in April 2016. Working from a 1,500-square-foot studio in the Queen West neighborhood, Jennifer and her team create "designer's choice" arrangements with the best, locally available varieties. Consistently voted Toronto's Best Florist, they have ignited a passion for Ontario flowers from the "wild north."

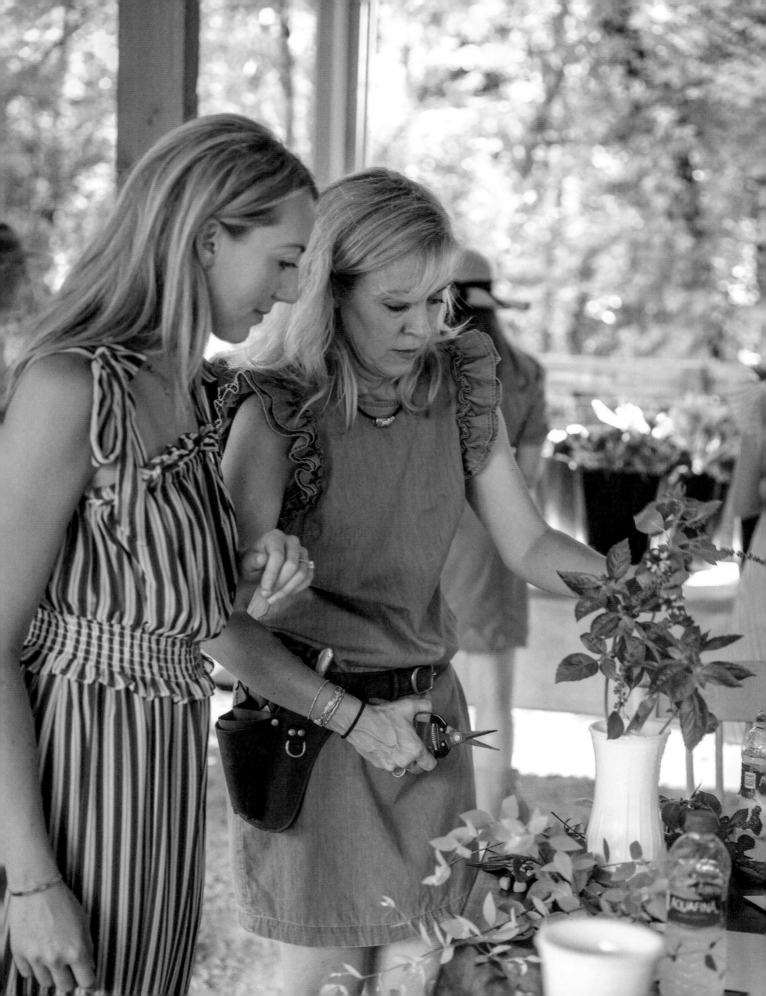

flora & fauna

BOTANICAL TOURISM CONNECTS
FANS TO A SMALL-TOWN FLOWER
AND SHEEP FARM

Natasha McCrary, 1818 Farms

Mooresville, Alabama

1818farms.com, @1818farms

Olivia Reed Photography

Located on three acres in the historic village of Mooresville, Alabama (population 58), 1818 Farms is named for the year the town was incorporated, one year before Alabama's statehood. Natasha McCrary and her family host all types of floral-inspired events here, in the fields, the Garden House, and under an open-air pavilion.

Measuring 30-by-32 feet, the pole barn-style pavilion is an ideal setting for workshops and events, giving guests views of 1818 Farms' flower garden and the Wheeler National Wildlife Refuge. Lighting and ceiling fans make summer and nighttime events especially comfortable for guests.

What began in 2012 as a family project to help her eight-year-old son care for a herd of Olde English Babydoll Southdowns sheep, has developed into a multifaceted agri-tourism destination and a line of farm-based bath, beauty, and lifestyle products sold by 500 retailers across the U.S.

> "I see the joy they bring to people, the connection flowers make, the stories customers tell us about a certain flower in their lives. You don't really hear that about produce."

"We wanted to teach our children about sustainability, working the land, and doing something as a family," Natasha explains. She soon discovered that thousands of other folks also wanted the 1818 Farms' experience, flocking to Open Farm Days, Bloom Stroll & Bouquet Workshops, garden club gatherings, and other farm-based education. More fans discover the farm through its popular YouTube channel where Natasha introduces viewers to sheep shearing, dried flower bouquet-making, and other everyday farm activities.

After initially growing a mix of 25 percent flowers-75 percent produce for area farmers' markets, 1818 Farms switched entirely to flower production in 2018, offering a local bouquet subscription service.

"Flowers allow us to have something to sell almost 12 months of the year," Natasha explains. "I see the joy they bring to people, the connection flowers make, and the stories customers tell us about a certain flower in their lives. You don't really hear that about produce."

When flower lovers arrive for a hands-on design workshop, Natasha covers cut flower growing methods, and shares tips on planting, harvesting, and conditioning, and then invites students to assemble bouquets beneath the pavilion. "We set up buckets filled with all their flower choices and teach step-by-step design," she explains. "We always encourage them to go out and cut more from the fields, which I think is important. People don't need more things. They want to connect with nature and have experiences."

the drying barn

A MODERN FLOWER FARM
BRINGS NEW PURPOSE TO A
CENTURY-OLD BARN

Jessica Hall, Stephanie Duncan
and Chris Auville, Harmony Harvest Farm

Weyers Cave, Virginia

hhfshop.com, @harmonyhrvst

HC Photography

Harmony Harvest Farm is a three-generation agricultural enterprise established in 2011 when Jessica and Brian Hall purchased a historic farmhouse with an 1890's bank barn on 20 acres of fertile rolling fields in Virginia's Shenandoah Valley. Jessica parents, Chris and Martin Auville, live a few miles down the road, and Stephanie Duncan, Jessica's sister, resides in the same community with her husband Zane.

A female floral trifecta, Chris, Jessica, and Stephanie run Harmony Harvest's cut flower operation, intensively farming more than 200 botanical varieties on seven-plus acres and inside seven growing houses, with continual plans to expand. Additionally, Jessica and Stephanie own Floral Genius, a floral accessory manufacturing venture that produces metal pin and cup floral frogs.

Chris (business manager), Jessica (farmer-florist), and Stephanie (marketing and social media manager) make sure there is constant laughter in their busy days. The women regularly film videos of life at Harmony Harvest, including their popular "Live from the Cooler" series, and a tongue-in-cheek YouTube show called "Designing with an Idiot."

They loved visitors' reactions to Harmony Harvest's iconic red bank barn, which basically sat unused for years, other than providing storage. As their wholesale and mail-order cut flower business expanded, demand for dried flowers also increased — and the 30-by-60-foot barn provided a solution. "It wasn't the most sound and safe, even though it was updated in the 1970s with a metal roof and siding," Jessica says. "So, we spent the 2020 season firming up the foundation to make it completely usable."

Earlier owners ran a commercial cattle operation here, storing hay in the barn. For Jessica, Stephanie, and Chris, the soaring interior space, its ceilings crisscrossed with rafters and beams, is now ideally

"We are relying on old agricultural practices to dry flowers and our barn is reliving its best life."

suited for strings of marigold garlands and hundreds of dried flower bunches, ranging from massive hydrangeas to delicate statice. It's also a welcoming event space for workshops and holiday festivals.

The women marvel at the marketplace demand for dried florals. "We have figured out how to make a perishable product – fresh flowers –not so perishable," Jessica says. "And we attribute so much of our success to the barn."

Original wood sideboards are preserved inside, reminiscent of this structure's past. "This was a drying barn from the very beginning, but it was just used for a different crop," she adds. "Now we are relying on old agricultural practices to dry flowers and our barn is reliving its best life."

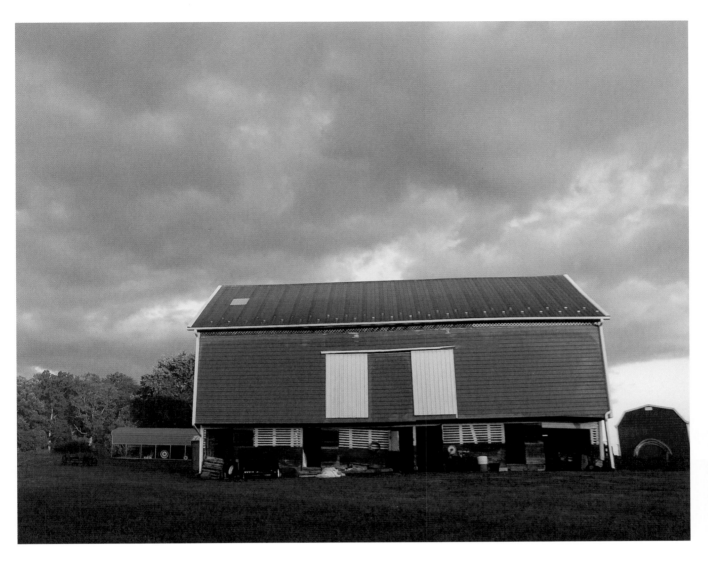

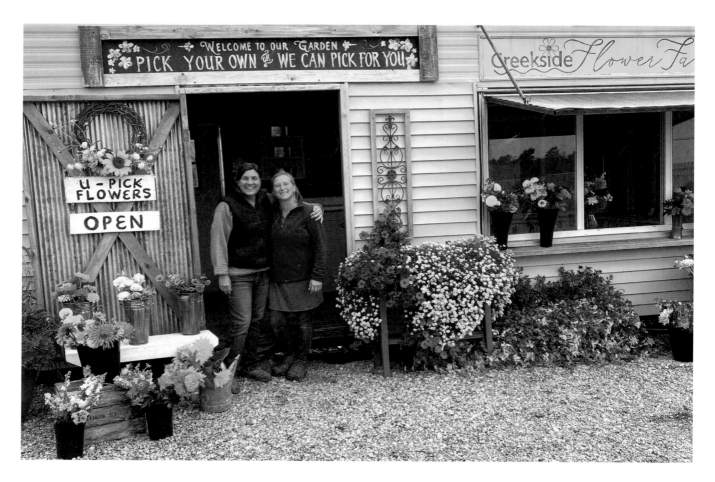

the flower wagon

A GARDEN CENTER ADDS A CUT FLOWER FARM, YOU-PICK FIELDS, AND FLORAL DESIGN SERVICES

Sue Dykstra, Creekside Growers & Farmer Florist

Middleville, Michigan

creeksidegrowers.com, @creeksidegrowers

Kelly Lewis Photography

"People know we grow plants, but cut flowers are a whole new avenue for us."

Sue Dykstra is an experienced plants-woman, having operated nurseries for a decade before opening her own a garden center in 2001. Creekside Growers began as a small plant stand on the Dykstra family property in Western Michigan and has since expanded to 65,000-square-feet of covered greenhouses and garden center, plus display gardens and two acres of cut flowers.

Sue added "Farmer Florist" as a tagline five years ago, bringing a cut flower focus to the nursery. Seasonal flower crops, you-pick fields, CSA subscriptions, and wedding flowers serve this rural community that has few other options for local flowers.

"People know we grow plants, but cut flowers are a whole new avenue for us," she explains. "We are growing those special varieties that can't be shipped, like lisianthus."

In 2019, Kelly Lewis joined Creekside Growers to help Sue realize her vision for flower farming. Kelly originally earned an industrial design degree, worked for a Michigan greenhouse, and managed a bakery, before she was ready to "be more creative, getting dirty, and working outdoors."

One of Kelly's first projects involved renovating a vintage 10-by-24-

foot trailer than once housed a donut shop. Renamed "The Flower Wagon," the sage green structure stands in the center of Creekside Growers' you-pick cut-flower fields. It is stocked with buckets of water and vases for customers to arrange their just-picked stems. "Customers bring in the flowers they have cut and use the countertops here to design their vases," Kelly says.

Nearby, a 16-foot-tall, polychromatic butterfly-and-pollinator plant mural, painted by Kelly, invites people of all ages to take selfie photographs among the flowers. "It's fun and enjoyable – and it's a reason for people to come to Creekside," Sue adds.

The women are expanding the cutting grounds to other areas of the property, recently adding 450 ornamental flowering shrubs that bloom from early spring to late fall, as well as 400 peony plants, to the established beds for a gazillion dahlias and garden roses. "We specialize in cut flower crops that many customers and florists in the Grand Rapids-Kalamazoo area have never seen before," Sue explains.

"When I hear someone say, 'I never knew you had this flower garden,' I know they'll tell their friends and come back."

"Customers may come to Creekside to engage with ornamental garden plants, and leave learning about locally-grown cut flowers," Sue says. The nursery hosts early season "potting parties" for as many as 600 locals each March. "People bring their planters; we give them the dirt," she explains.

"They shop for the plants they want and we help them put it all together." The nursery staff cares for hundreds of these container gardens until May when customers can take their creations home – after the threat of frost is over. By summer, the cutting gardens are a draw for popular "wine and design" workshops and other flower classes.

Ultimately, Creekside Growers is changing attitudes about the importance of locally-grown flowers. "We are a garden destination with a purpose," Sue explains. "The flowers are our main focus, but we want to make it fun, so people can experience our flowers while having a picnic, enjoying the beautiful views, taking a class, or shopping. When I hear someone say, 'I never knew you had this flower garden,' I know they'll tell their friends and come back."

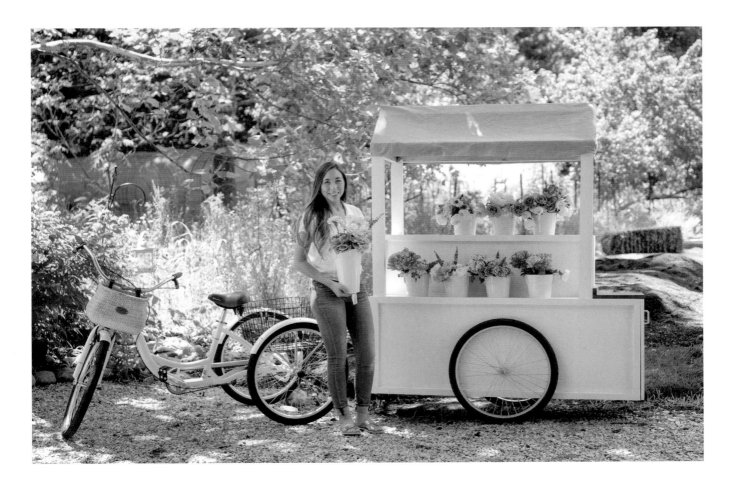

fleurs on wheels

A TRICYCLE BUILT FOR BLOOMS

Shelby Lung
Belle Fleur Flower Cart

Ozark, Missouri

@bellefleurflowercart

Shea Brianne Photography

"We have the most fun seeing how people pick our their flowers and share photos on instagram."

Destination wedding photographers Shelby and Jared Lung are a Midwest-based, husband-and-wife team who turn love stories into art for free-spirited couples. They also teach photography workshops and host styled photo shoots. And that's how the charismatic tricycle, now called Belle Fleur Flower Cart, came into their lives. As Shelby explains, they needed a cute prop for an engagement session for Rêver Workshops, which they host for professional photographers.

"After the workshop, it was just a big adult bicycle taking up space in our garage," Shelby says. "Cute, but we didn't know what to do with it." She asked her flower-farmer mother, Kelly Hill of Blossom Thyme Hill Flower Farm (see page 119), what to do with their tricycle. "Mom suggested it could be really cute to add a flower cart on the back. We decided we could take mom's flowers and sell them at farmers' markets and boutiques — and both make some money."

Jared spent three days sketching out plans and constructing the cart, complete with a cloth canopy and shelves for eight French flower buckets. Shelby and Jared now wheel their charming cart to local retailers who host pop-up flower events. They also rent it out for bridal showers and weddings. "We have the most fun seeing how people pick out their flowers and share photos on Instagram," Shelby says.

handcrafted

A FREE-SPIRITED PIONEER WOMAN GROWS FLOWERS AT THE EDGE OF AN OAK FOREST

Caitlin Jessen, Wandering Willow Farm

Garberville, California

wanderingwillowfarm.com, @wanderingwillowfarm

Caitlin Jessen Photography

If Caitlin Jessen needs something, she figures out how to build it — from a glassed-in greenhouse to raised beds for her cut flower production. She is naturally self-reliant, not just because it's economical, but because she learned carpentry from her father and food gardening from her mother.

Based in Northern California's Humboldt County, Wandering Willow Farm is a one-woman operation, situated on a hilly, wooded 60-acre homestead that Caitlin purchased four years ago with her brother. "I live in a tiny house, so I was looking for land to move it to," she explains. "When we bought this property, there was absolutely nothing here. No road, no water. I built everything I needed."

Wandering Willow Farm emerged from Caitlin's practice of growing flowers for herself and friends. "I was cutting an insane amount of flowers and bringing them to everyone. I also was trying to decide what to do for a career that allowed me to work at home and outdoors."

"I call it my flower office."

As it turns out, Caitlin's excellent gardening genes guided her choice. "I helped my mother tend to a huge vegetable garden and I even had my own little square in her garden where I grew flowers," she recalls. Today, her mother, who lives nearby, often helps with the flower farming. "She's my number-one flower picker," Caitlin says. "I pay her in flowers and coffee!"

Caitlin knew she needed a greenhouse for starting flats of seeds. With her father's help, she designed and erected a 10-by-12-foot structure with salvaged windows, doors, and other building material. A focal point of the farm's "lower garden," the greenhouse is reached by a central path bordered by two 8-by-50-foot raised beds. There, annuals, bulbs, and herbs flourish throughout Northern California's long growing season.

A screened-in porch attached to her farm's storage shed serves as a design studio. The breezy environment keeps flowers cool until Caitlin makes local deliveries or transports buckets of bouquets to her stall at Garberville Farmers' Market. "I call it my flower office," Caitlin explains. "I've always wanted to do something I love in a place that I love."

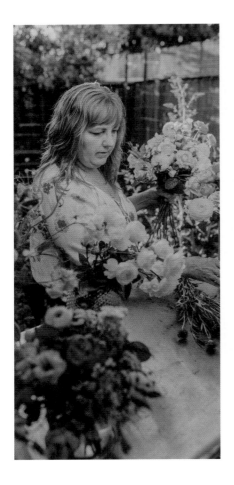
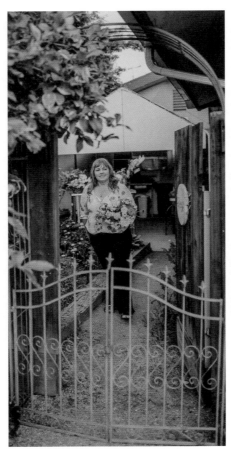
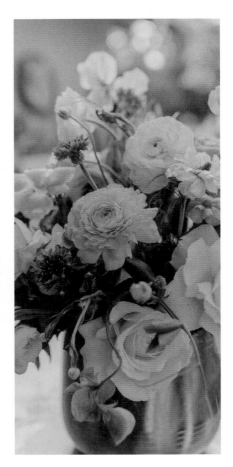

a studio in the garden

JUST STEPS FROM HER DOOR

Laurie Garza, Fleurie Flower Studio

Reedley, California

fleurieflower.com, @fleurieflowerstudio

Liz Noel Photography

"Being an artist, I need to see how things work together. I have to be amongst the flowers."

Laurie Garza's tagline is "Thoughtfully Crafted Seasonal Flowers." Since opening Fleurie Flower Studio in 2010, her interest in locally grown flowers has increased, thanks in large part to a one-quarter-acre residential lot that supplies blooms for intimate events and everyday arrangements. "Once you get hooked on local flowers, it's so hard to go back and buy commercially-grown ones," she says.

Laurie has devoted nearly 6,000-square-feet to her flower garden, including more than 100 rose shrubs. Laurie converted a bonus room on one side of her home for her studio. Having a home-based studio, complete with flower coolers, a commercial sink, and worktables, makes it all possible. A doorway opens onto a side yard where tables hold trays of seedlings and where Laurie processes her cut stems.

The season begins early each year with flowering branches and spring bulbs. Early-summer roses and perennials and late-summer dahlias and annuals follow. There are times when she has to supplement her own harvest by ordering from California wholesale sources, of course. But her desire is to rely as much as possible on her garden's prolific harvest. Fleurie's online shop promises "designer's choice," which means customers receive the best available blooms. "I love being able to walk into the garden and choose something. Being an artist, I need to see how things work together. I have to be amongst the flowers."

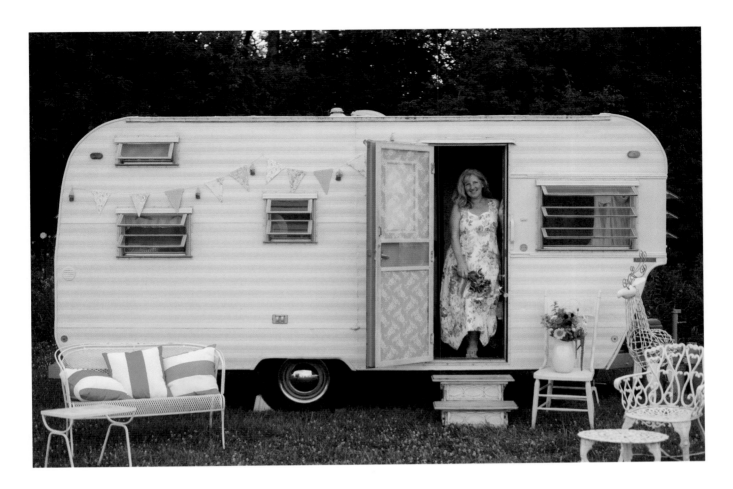

meet 'glory the glamper'

A 1960s TRAILER IS DRESSED UP AS THE FOCAL POINT OF A U-PICK FLOWER FARM

Linda Spradlin
In the Garden Flower Farm

Seven Mile, Ohio

@inthegardenflowerfarm

Maudie Conrad Photography

"Sharing is a big thing for me. That's why I love it when people come here."

When she and her husband purchased the 10-acre field opposite their home, Linda Spradlin began to dream of growing flowers there.

A habitual shopper of antique shows and flea markets, Linda also viewed the field as a spot for her vintage garden collections. In 2015, she combined her two passions to create In the Garden Flower Farm, which has blossomed into a popular U-pick destination.

"Like everything else I do, it evolved. I started with a few rows. I read a lot, went to meetings, and met other flower farmers," Linda explains. "I also knew I wanted a camper for the field. I thought it could be an office that would save me from running back and forth to my house."

Linda found the 1968 'Fan Camper' on Craigslist. She and her family repainted it white and pink, giving her the name 'Glory the Glamper.'

Now surrounded by a dozen 70- to 100-foot rows of sunflowers, zinnias, rudbeckia, gomphrena, and amaranth, the whimsical Glamper always puts a smile on people's faces.

"I just love my little camper here at the heart of my farm." Guests clip flowers for their Mason jar arrangements or fill up three-gallon buckets to take home with them. "Sharing is a big thing for me. That's why I love it when people come here."

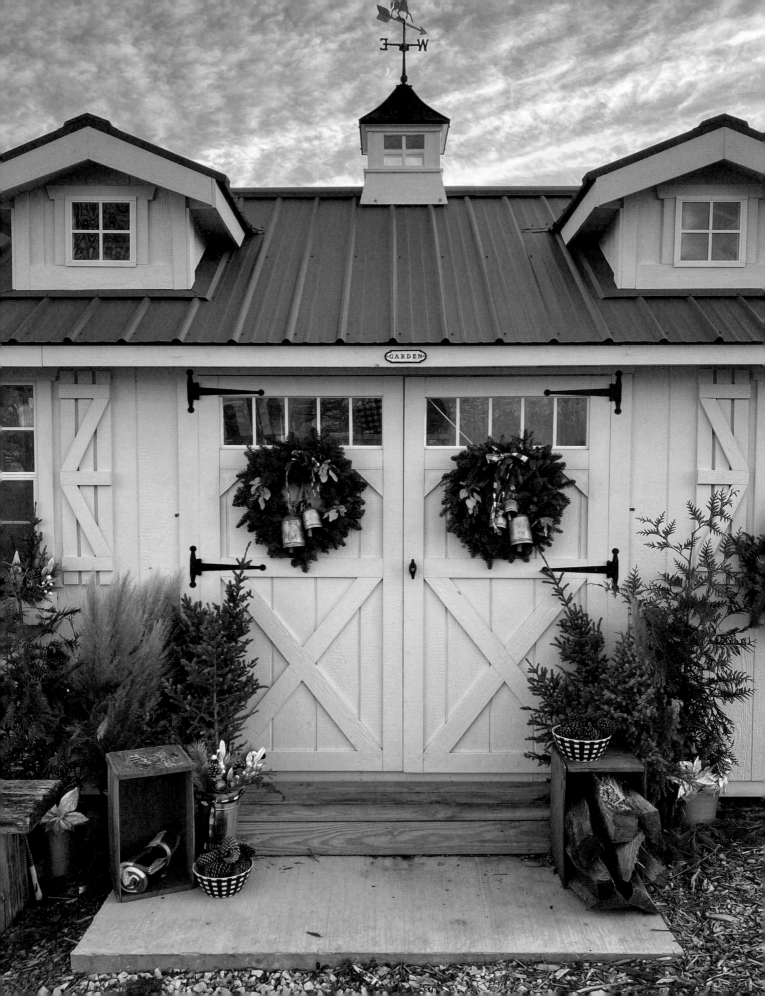

living among the lavender

A CREATIVE COUPLE DRAWS PEOPLE TO THEIR FARM WITH BOTANICAL EXPERIENCES

Adam and Jennifer O'Neal
PepperHarrow Farm

Winterset, Iowa

pepperharrowfarm.com, @pepperharrow_

PepperHarrow Photography

"The lavender has taken on a pretty large role, one that we've enjoyed, and people go gaga for."

Jennifer and Adam O'Neal graciously welcome flower-seeking visitors to PepperHarrow Farm, their 20-acre homestead located in Iowa's famed Madison County. Since establishing the farm in 2011, their first love — growing specialty cut flowers for their community — has broadened into a mission to connect people everywhere with those flowers, through in-person workshops and online education, botanical products and flower subscriptions. Adam and Jennifer knew they wanted to build a farm-based life for their family, including three children. Their talent for growing flowers has expanded from farmers' markets and designing for weddings to include online and in-person education and farm-based experiences.

Much of their activities revolve around two inviting buildings situated among fields of dahlias, peonies, sunflowers, lavender, and more than 75 other botanical varieties. The 1,200-square-foot "Event Barn" was once a horse stable and tack room. Now, it's a people-friendly gathering space, updated with white-washed walls, cafe lighting, vintage furniture and home to workshops that teach seed starting, floral design, a lavender grower's intensive and coffee and tea tastings.

There's plenty of space for a "king's table" that seats 36 guests at farm dinner collaborations with local chefs. Overhead, a salvaged log hangs from the rafters, a piece Adam found while walking their property. He

LUCAS LEELAND PHOTOGRAPHY

"It was the cutest thing ever: the windows, the flower boxes, the dormers and the cupola — I had to have it!"

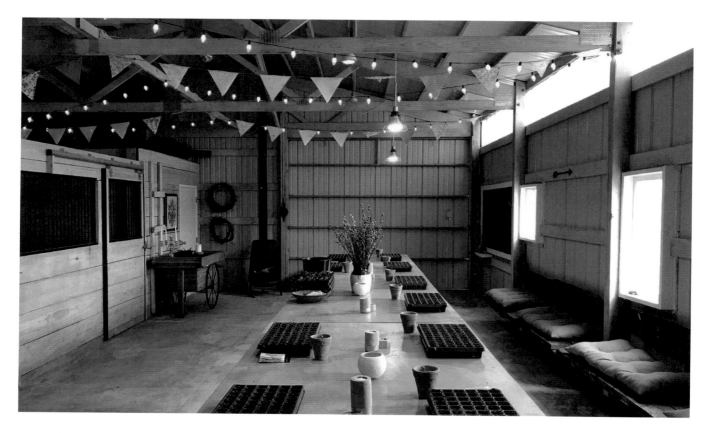

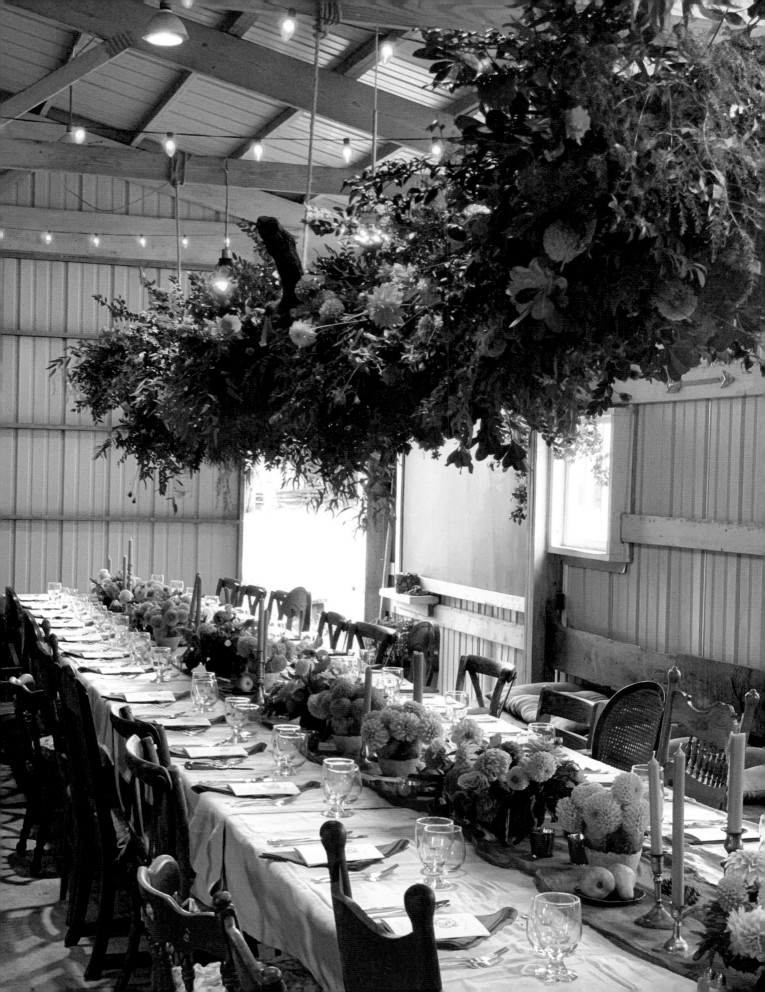

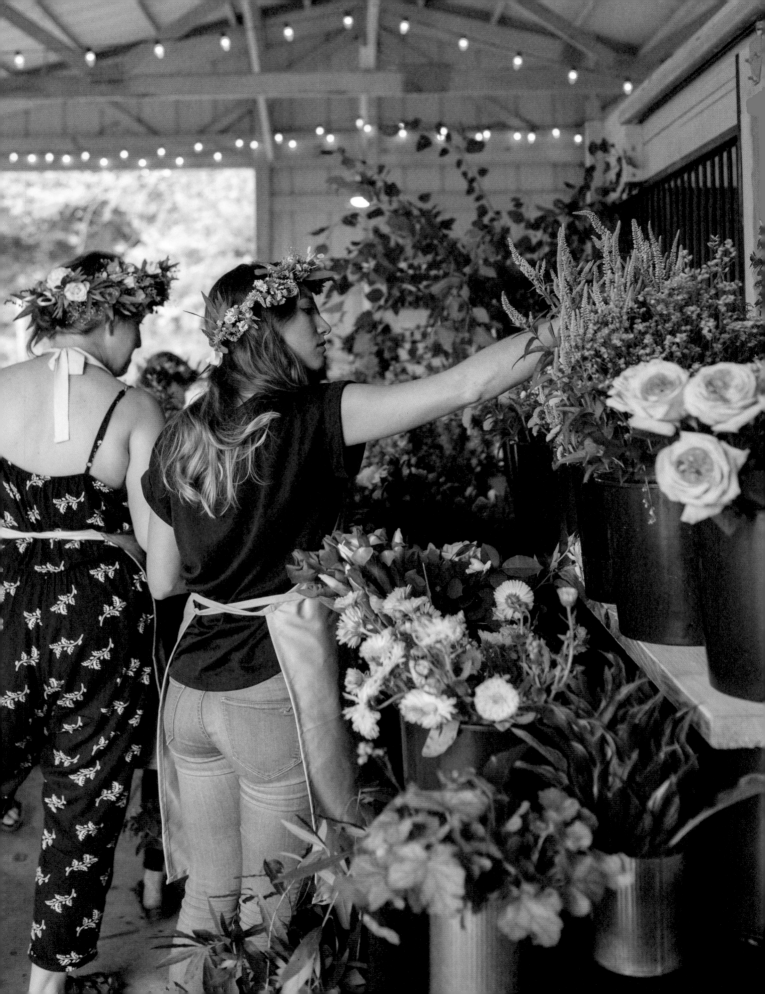

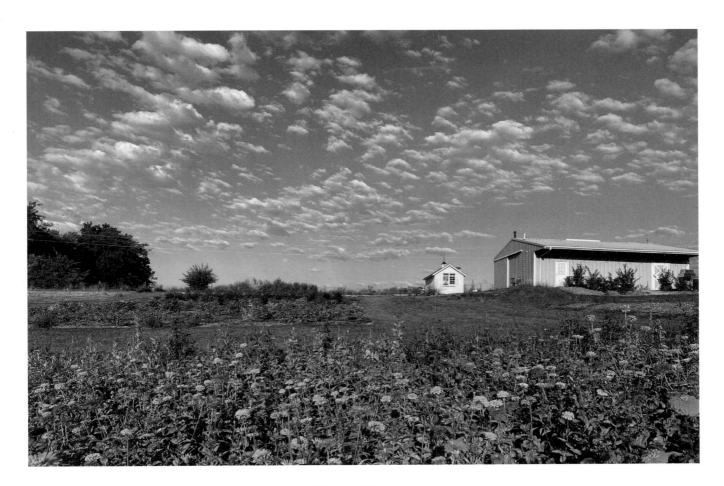

transformed it into an organic sculpture, ready to be "flowered" for festive occasions.

Sliding doors open wide to views of the flower fields beyond. The bountiful setting entices those who gleefully grab clippers when Jennifer and Adam send people outdoors to pick their own blooms.

In 2019, Jennifer fell in love with a 10-by-20-foot cottage displayed at a local flower and garden show. "We'd been thinking, 'How do we bring more people out to experience the farm?'" she explains. "It was the cutest thing ever: the windows, the flower boxes, the dormers and the cupola — I had to have it!"

The cottage has quickly become an iconic feature at PepperHarrow. Indoors, it's a retail shop for the farm's line of lavender products and CSA pickups; outdoors, it's become a canvas for Jennifer's large-scale floral installations and a popular backdrop for photographers.

When subscribers pick up their flower, herb, or plant shares, "We encourage them to leave their flowers in the cottage and take a tour around the farm before they go home," Jennifer says. Tours inevitably lead people to a gorgeous, half-acre planted with tidy rows of aromatic lavender. As Adam explains, "We knew we needed multiple sales channels to make this farm work for us. The lavender has taken on a pretty large role, one that we've enjoyed, and people go gaga for." A new distillation system has boosted production of lavender oil for candles, bath and body products, and other items. As the lavender fields mature, there's no doubt that more customers will discover and be mesmerized by a bit of Provence on a farm in Iowa.

"We encourage people to leave their flowers in the cottage and take a tour around the farm before they go home."

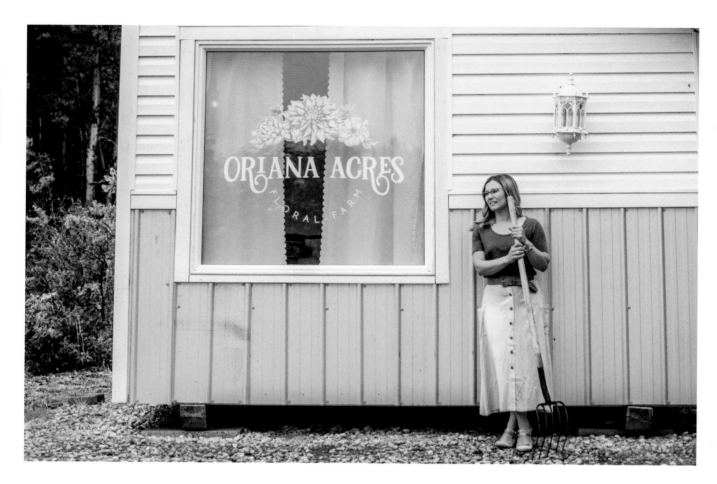

a floral destination

A MODERN WORKSHOP AS FOCAL POINT FOR GROWING, DESIGN, AND EDUCATION

Matti Harper, Oriana Acres

Kamloops, British Columbia

orianaacresfloralfarm.com, @oriana.acres

Emily Jane Photography

"My mindset shifts to creativeness here."

Matti Oriana Harper always loved her unique middle name, which translates as "gold rising" or "sunrise." So, in 2017, when she and her husband Landin Sanregret established a flower farm in Dawson Creek, British Columbia, the small agricultural community of her childhood, Matti called her venture Oriana Acres.

"I knew I wanted to do something more vibrant and creative, with more entrepreneurial freedom."

Located on 90 acres in the Peace Region of northern B.C., reached driving 750 miles by car from Vancouver, Oriana Acres produces a colorful array of field-grown and greenhouse crops. Matti marvels that "I've been able to pull off a successful flower business" within the constraints of a short growing season and harsh climate.

Oriana Acres' headquarters began at her kitchen table, which the little farm quickly outgrew. That's when her carpenter-parents stepped in with a solution. "My mom designed the studio for me, and both my parents built it," she explains.

"I do everything here – from starting seeds to designing bouquets," Matti says. "My mindset shifts to creativeness here. It's so important to work in the right space, one that's finished simply and painted white. This studio became the image of my business."

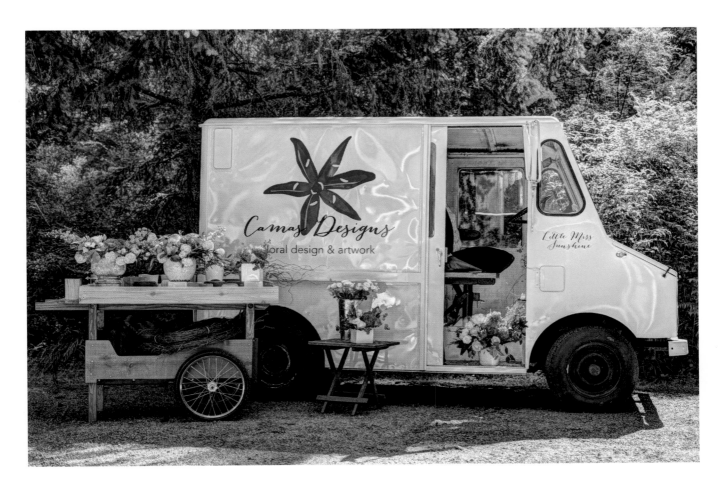

'little miss sunshine'

LOCALLY-SOURCED HAPPINESS

Erin Shackelford, Camas Designs

San Juan Island, Washington State

camasdesigns.com, @camasdesigns

Robert Shackelford Photography

"To me, the camas flower symbolizes hope and a sense of place. It reminds me of the peace I experience in the island's naturally gorgeous setting."

Erin Shackelford claimed her new, flower-filled lifestyle and its intentionally small footprint after decades in corporate America, most recently as vice president of human resources for a biotech firm. Walking away at the height of her career for a more soulful existence on San Juan Island, north of Seattle, "was one of the few steps in my life I didn't over-think and I've never regretted it," she laughs.

Erin recalls making bouquets for family and friends when she was eight years old. She reclaimed the practice and a desire to immerse herself in nature, forming Camas Designs in early 2016 and choosing the native Pacific Northwest flower often found thriving along hiking trails in the San Juan Islands as her muse. She found and restored a 1984 U.S. Postal Service delivery truck-turned-ice cream truck. "Naming her 'Little Miss Sunshine' was obvious. The highlight for me is seeing people's faces when I'm driving around the island. When they see the truck, I see them smile, and that's pretty awesome."

Often after installations and events, Erin repurposes flowers into small jam-jar posy arrangements, delivering them in Little Miss Sunshine to retirement homes and around her community. Thus, the FlowerBomb4Love Project was born. "It's just to try and give people a little hope that there's still some love out there in the world."

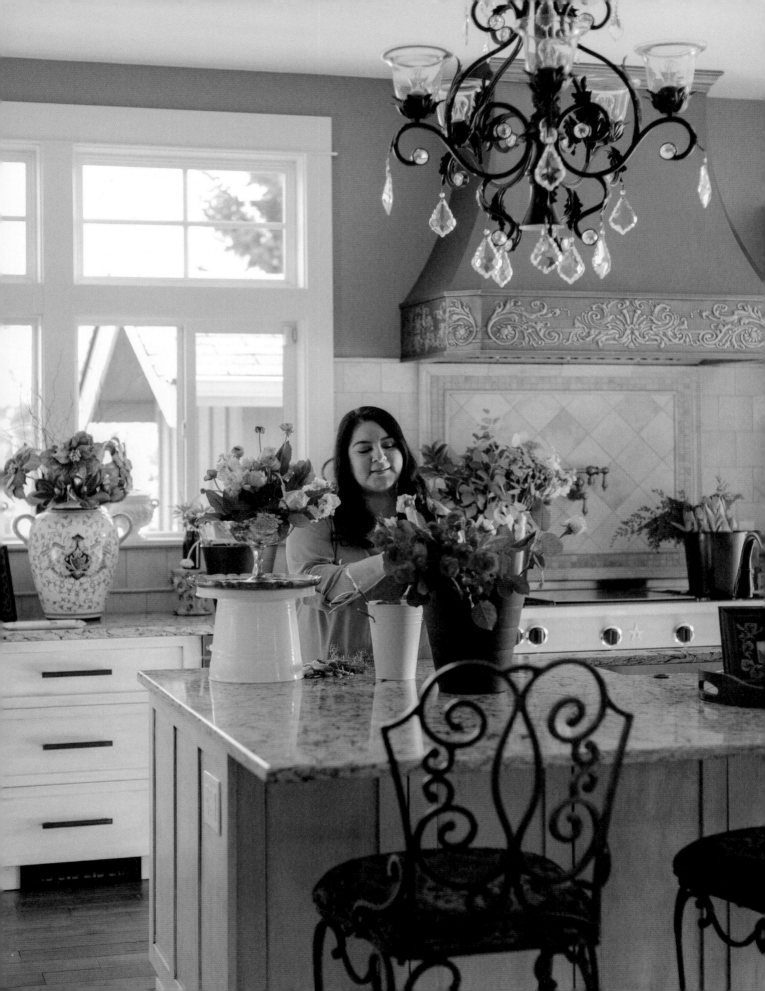

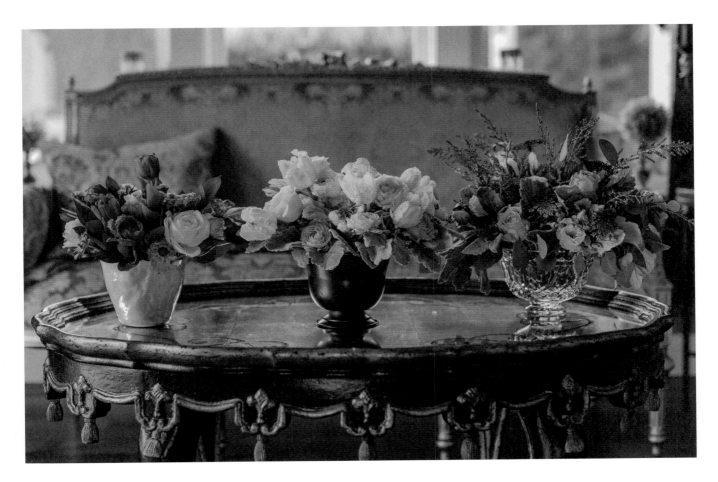

a place for her petals

DRAWING INSPIRATION FROM HOME AND GARDEN, A STUDIO DESIGNER GETS STARTED

Teresa Rao, Belle Pétale

Seattle, Washington

@belle_petale_

Missy Palacol Photography

"I want to make sure I'm supporting famers who are growing domestic flowers."

Teresa Rao is an avid gardener and flower lover who in 2020 transitioned from a 16-year corporate training career to floristry. Basing her design studio at home, where she can clip foliage and blooms from her garden while also parenting her seven-year-old daughter, "is where I need to be," she says. "I definitely consider myself a 'gardener-florist.' My garden is classic and romantic. I love to grow roses and perennials."

The studio name, Belle Pétale, comes from a childhood love of petals (Teresa and her sister were frequent flower girls for relatives' weddings) and a passion for all things French. A recent kitchen remodel was designed with her floral studio in mind. "My kitchen island serves as 'my design spot'." The family hub is quickly transformed into a studio when Teresa designs arrangements for her weekly deliveries or pop-up sales hosted by other businesses. "My flowers take over," she laughs.

When she needs more than her garden provides, Teresa turns to a farmer-owned cooperative and smaller growers nearby. "I want to make sure I'm supporting farmers who are growing domestic flowers," she says. "I always share where my bouquets are sourced and I use hashtags like #supportyourlocalflowerfarmers, drawing attention to the mission that my business is part of while educating my clients and the public about why it's important."

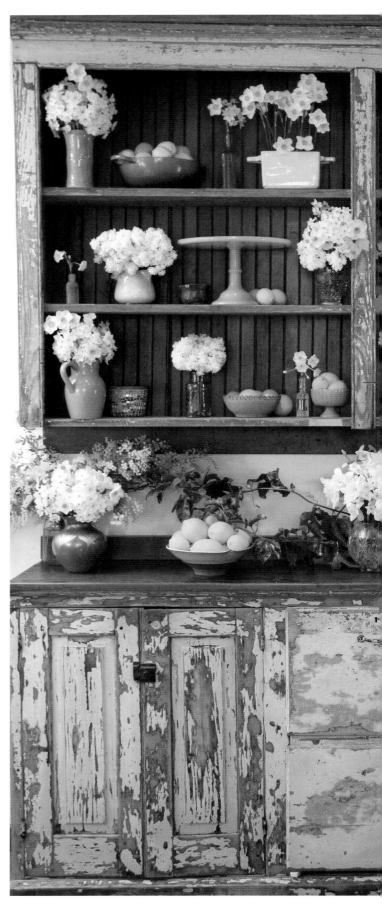

the posy express

A BOUNTIFUL ORGANIC CUTTING GARDEN PAYS HOMAGE TO THE OLD WEST

Laura Cohen, The Posy Express

Carmel Valley, California, @theposyexpress

Laura Cohen Photography

Two acres planted with heirloom cottage garden varieties, cultivated California natives and wildflowers yields a proliferation of seasonal bouquets for Laura Cohen's customers in Carmel Valley, California. The first iteration of her local-floral enterprise was a kids' flower stand. "Back in 2013, my daughter and her friends plopped themselves by the oak tree on our road and sold my flowers to whomever drove by," Laura recalls.

Later, her love for growing cut flowers evolved into The Posy Express, represented in a logo of a cowgirl on horseback carrying a posy, a concept Laura and her mother first sketched.

In addition to clipping from her ornamental borders, Laura maintains 35 raised beds of varying dimensions, the bottoms of which are "gopher-proofed" with galvanized wire panels. There are three separate cutting garden areas and 130 roses, comprising a "mini-mini-flower farm," Laura laughs. "No-til organic methods, soil health, and regenerative agriculture are passions of mine. Composting and gray water irrigation are important elements, and the chickens are my favorite gardening tool – they eat the cover crops and turn that into organic matter to fertilize the garden all at once."

"I always have plenty of flowers."

As she cuts her flowers, Laura gathers the stems into posy bouquets, typically sold in Mason jars. Her design studio occupies a sunroom with a utility sink, plenty of countertops, and beautiful light. An antique hutch displays Laura's collection of vessels.

Laura delivers just-picked flowers to area restaurants, coffee shops, hotels, and private residential clients. She also has cultivated a floral partnership with Jane Hand of Jane's Workshop (see page 48), a Carmel Valley florist who loves to design with Laura's seasonal blooms, herbs and foliage. Located just two miles down the road from one another, the women frequently collaborate, swap plants, and experiment with uncommon berries and foliage found in the hedgerows of Laura's garden. They also head to San Benito County to collect pruned grapevines and responsibly wild-forage on family ranchland.

"My goal is to provide beautiful, fresh, field-grown flowers and foliage year round for our customers and select, local florists," Laura says. "I always have plenty of flowers."

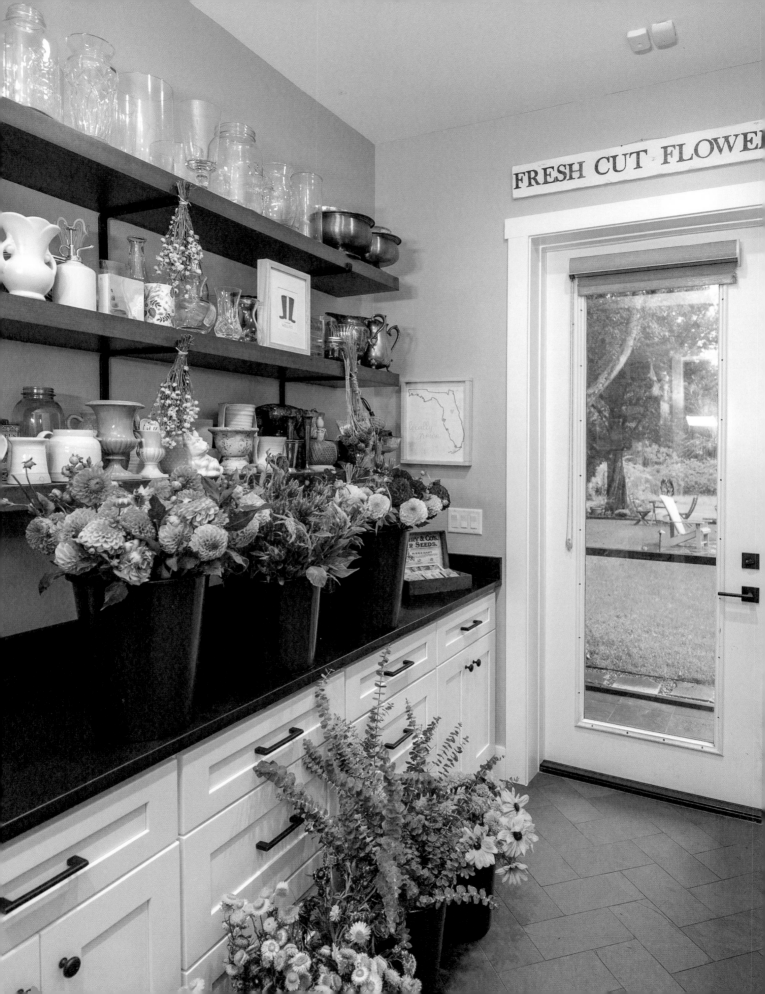

FRESH CUT FLOWER

grower's choice

COMPACT AND EFFICIENT,
A STUDIO REFLECTS A
FARMER-FLORIST'S
POSITIVE OUTLOOK

Eileen Tongson, FarmGal Flowers

Winter Park, Florida

farmgalflowers.com, @farmgalflowers

Sebastian Tongson Jr. Photography

"It's Florida and it's my style.
We have sunshine in our
palette."

Eileen Tongson is an urban flower farmer and designer whose harvest supplies events and workshops. Based in an Orlando suburb, she lives on three-quarter-acres, rare for the neighborhood, but exactly what FarmGal Flowers needs. Since 2014, Eileen has also tended and taught in a 3,000-square-foot garden at Orlando's East End Market, a neighborhood food hub promoting Florida's farmers and artisans.

Desiring more growing space but wanting to stay close to family schools and work, Eileen and her husband Sebastian Tongson found a 1970s home in Winter Park in need of an upgrade. "I remember when we went to look at it," she laughs. "I walked through the house and went straight to the backyard." The sunny property is ideal for growing flowers and is also private as it overlooks a creek and a local botanical garden in the distance.

As part of their home's renovations, the contractor enclosed part of an outdoor patio to capture a pint-sized footprint for Eileen's studio. Resembling a chef's galley and well-organized, the 120-square-foot space contains a tiny floral cooler, two long work counters, open shelving for vases, and an extra-deep sink for filling flower buckets.

Eileen's cutting garden is located steps away, accessed by a studio door. "I see my work reflected by my studio and garden," she says. "I love bright colors. It's Florida and it's my style. We have sunshine in our palette."

the farm shop

**TWO FLOWER GROWERS
OPEN THEIR DOORS FOR
ON-FARM RETAIL**

Teresa Engbretson and Katie Elliott,
My Garden Over Floweth

Paterson, Washington

mygardenoverfloweth.com,
@mygardenoverfloweth

"We want people to see what
we do and why we do it."

In 2012, after she and her husband sold the family's 1,500-acre onion farm, Teresa Engbretson planted a small patch of cut flowers in Paterson, Washington, and began to sell bouquets at a local farmers' market. As the venture grew, Katie Elliott joined her mom in 2013 as creative partner, bringing with her a background in apparel merchandising and marketing.

Today, nearly a decade later, Katie and Teresa's farmer-florist enterprise is called My Garden Over Floweth, a fitting name for their multi-faceted enterprise that at times feels more than abundant. The women now raise more than 100 flower varieties on three acres at the edge of Washington's Columbia River.

Their sheer volume of blooms supplies local wedding clients, area farmers' markets, and customers who visit the Farm Shop. Their customer base includes loyal fans from their small community and those who travel distances to experience a real flower farm. Added in 2018, the 5,000-square-foot Farm Shop has allowed the women to move out of Teresa's garage. The new building is the main attraction during intimate farm dinners and seasonal flower and artisan festivals (called "Spring Fling" and "Fall Fling") that draw 1,500 guests.

"We want people to see what we do and why we do it," Katie says. "It's agritourism, but it's also about making connections and relationships."

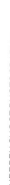

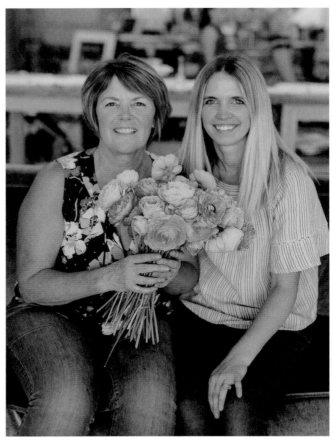

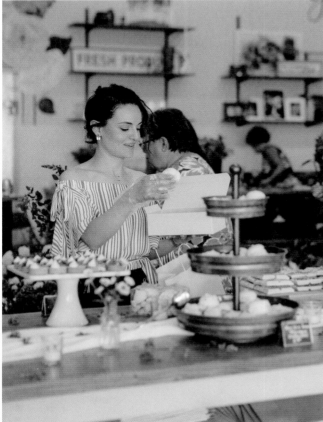

ALEX LASOTA PHOTOGRAPHY (all images)

two-part harmony

SISTERS COMBINE FLORAL DESIGN WITH A PASSION FOR EDUCATION

Kit Wertz and Casey Schwartz, Flower Duet

Los Angeles, California

flowerduet.com, @flowerduetla

Randy Schwartz Photography

"This space has given us the freedom to store our floral supplies and also be able to teach 50 people."

Casey Coleman Schwartz and Kit Coleman Wertz, partners in the aptly named Flower Duet, manage a diversified, full-service enterprise based in Los Angeles's South Bay. It often feels like all roads lead to Flower Duet, thanks to easy access via many L.A. freeways to reach their 4,500-square-foot studio, home base for floral production, workshops, and filming online tutorials.

Flower Duet is located a few miles from Pacific Coast beaches, in close proximity to popular wedding venues, and 30 minutes from the Los Angeles Flower District, where Kit and Casey got their start as entrepreneurs. Drawing from Casey's first career as social staff (and floral designer) on cruise ships, and Kit's background in media and marketing, the sisters invited friends to shop with them at the L.A. Flower District. "We taught our friends how to arrange flowers and that led to requests to design for weddings," Kit recalls.

They formed Flower Duet in 1999, running it as a side business. Ten years later, both women had young families and wanted flexibility, so they left other careers to focus on Flower Duet. Casey's husband, commercial advertising photographer Randy Schwartz, had leased a large studio in Torrance and Flower Duet moved in as well. Today, Flower Duet occupies more than half of that space, and Casey jokes that it's lucky Randy is often away on location, "because we've moved him into one corner."

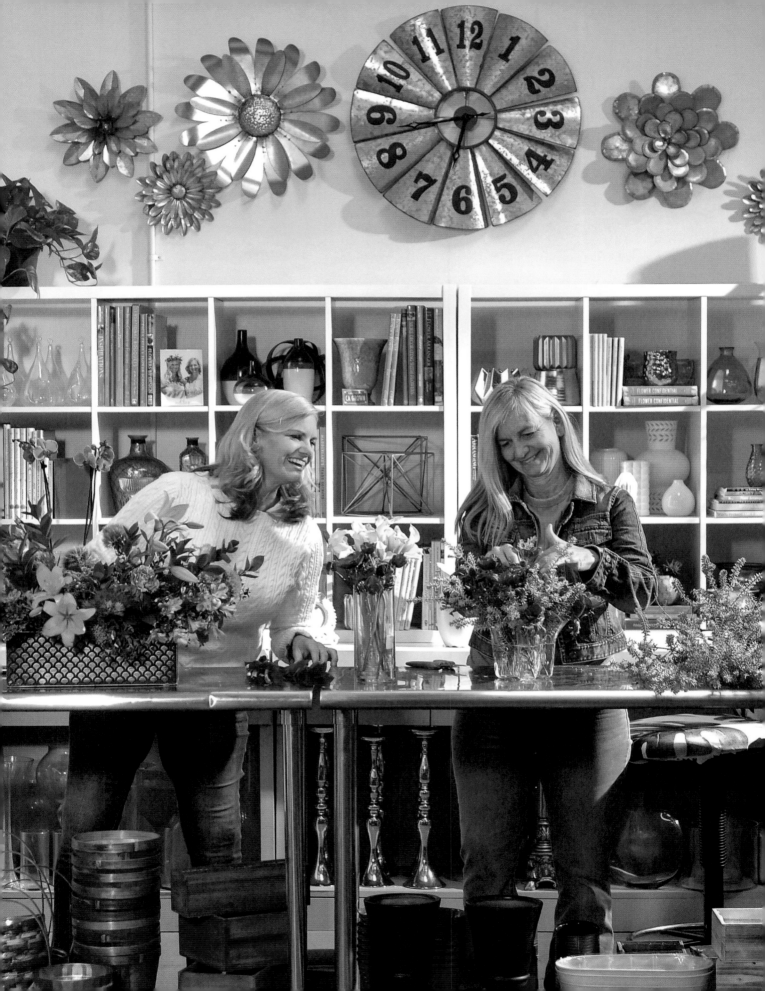

The industrial warehouse has many benefits including 30-foot ceilings that allow for upper-level prop and vase storage and a massive garage-style door that opens to flood the interior space with light. Many workshops move outside, especially messy ones like Living Art Camp, Flower Duet's popular children's program, and succulent pumpkins and wreath-making classes. All is made easier because Casey has designed a movable setup with everything on wheels – from tall metal storage racks to 20 stainless-steel culinary prep tables (each with a lower shelf to hold stools and student supplies).

This versatility accommodates one-on-one teaching for aspiring professionals and larger group design classes. When Kit and Casey want to build a large topiary animal or make an arch sample to show a wedding client, they just move racks and tables to the side. When the weather is too windy or rainy, they back in their vehicles for loading large or delicate arrangements.

"We want people of all ages to have the 'life skill' of flower arranging."

"This space has given us the freedom to store our floral supplies and also be able to teach 50 people," Casey explains. "There's free parking for everybody (a Los Angeles rarity) and the studio has wheelchair accessibility. Just having the access is a big perk."

The studio doubles as a filming set for frequent Zoom tutorials for corporate groups and online courses, including a kid-based series called "Living Art Camp" and "Flower Arranging Fridays," a subscription program for flower enthusiasts.

Education is at the core of Flower Duet's mission as the sisters enjoy teaching DIY brides to design their wedding florals and have created a series for local cultural institutions including famed the Huntington Library, Art Collection and Botanical Gardens, and the Autry Museum. "It's reputation management," Kit explains. "Whoever we associate ourselves with, it's part of our brand and an endorsement of Flower Duet."

Adds Casey: "We want to teach not just the 'how' but the 'why.' We want people of all ages to have the 'life skill' of flower arranging – from children to adults who are finally learning how to make a grocery bunch of flowers look pretty." Always community-building, Flower Duet is based on relationships. Clients and students alike feel included in the warmth of two sisters who love collaborating with one another.

nature meets art

FLOWER FARMING INSPIRES HER WHIMSICAL BOTANICAL ART

Tamara Hough, Morning Glory Flowers

Glenville, West Virginia

morninggloryflowerco.com,
@morning.glory.flowers

"When my art helps people remember flowers, it's a great connection to make."

The floral illustrations Tamara Hough posts on Instagram capture the viewer's imagination, her portraits brought to life with just-picked petals and stems.

Tamara "paints" tiny, three-dimensional personalities using bits and pieces gleaned from her micro flower farm. Each image begins with a sketch. Then, she lays flowers and botanicals in place prior to photographing the final piece.

A former high school art teacher, Tamara makes art at Morning Glory Flowers in Glenville, West Virginia, where one-half acre of the 40-acre family farm is devoted to growing flowers. She sells bouquets at two local farmers' markets and offers prints and cards through her Etsy shop. In 2020, Morning Glory Flowers added a 12-x-24-foot, Amish-made greenhouse, which now doubles as an art studio.

Where others view shattered petals or broken stems as garden debris, Tamara says, "I see a leaf that reminds me of a skirt or a piece of Celosia suggesting a beautiful hairpiece." It's inspiring to see an artist use the medium of flowers, which for Tamara means combining her fine art training with her passion for "growing" her own art supplies. "When my art helps people remember flowers, it's a great connection to make."

from her hands

A FLORAL DESIGNER FINDS
PERSONAL EXPRESSION
THROUGH LOCALLY-GROWN
FLOWERS

Srini Perera, Kreative Hands

Woodland Hills, California

kreativehands.com, @kreative.hands

Alex Austin Photography

Srini Perera's home-based floral enterprise reflects her values of hospitality, beauty, and community. Her design studio is an up-cycled laundry room, complete with countertops, shelves, a sink, and views of a lush, Southern California landscape. "I have a beautiful window that overlooks a gorgeous oak tree. It's serene and calm here."

Launched in 2001, Srini's studio is named Kreative Hands and her logo is an image of hands holding flowers – symbolic of her philosophy to make a difference in people's lives through "flowering with love."

"I love what I do," she confides. "I'm extremely busy with my clients because I enjoy going the extra mile." It's important to Srini that she exceeds expectations with personal details both small and large, such leaving a surprise gift at a couple's sweetheart table.

She describes her aesthetic as "natural, free-flowing, garden-style," influenced by the plant world. A born researcher, Srini is curious about flowers from around the globe, crediting friends and family from Australia, Sri Lanka, and England for introducing her to their gardens and native flora. Yet, her vast botanical vocabulary draws equal inspiration from the semi-wild Southern California landscape around her home and garden in Woodland Hills, north of Los Angeles.

Raised in Sri Lanka, with a B.A. in Economics, Srini came to floral design after a 12-year career in finance and raising twins, now young adults. She studied at Southern California School of Floral Design and marvels at how the "small flame" of her floral passion grew into a busy floristry practice from word-of-mouth referrals, a great online presence, and frequent repeat clients.

"I have a beautiful window that overlooks a gorgeous oak tree. It's serene and calm here."

Kreative Hands is a family enterprise. "I'm blessed to have such a creative family, including my daughter, who has degrees in both animal science and product development; my son, who is an engineer and a photographer; and my husband, who is also an engineer," she says. When their home was severely damaged by an earthquake in 1994, the family started over, designing and rebuilding their "dream home," including a dual-purpose laundry room/floral studio.

Today, Kreative Hands' productions also spill outdoors, to the balcony and garden. "We have lots of cactus and fruit trees," Srini explains. "Plus, I enjoy leaving flowers for neighbors to discover on their walks." While she forages for greenery and perennials from her garden, other design ingredients come from flower farms located along California's central coast.

"I've established relationships with many flower farms because I've personally visited them and met the owners and staff," she explains. "They're now my best sources for local flowers."

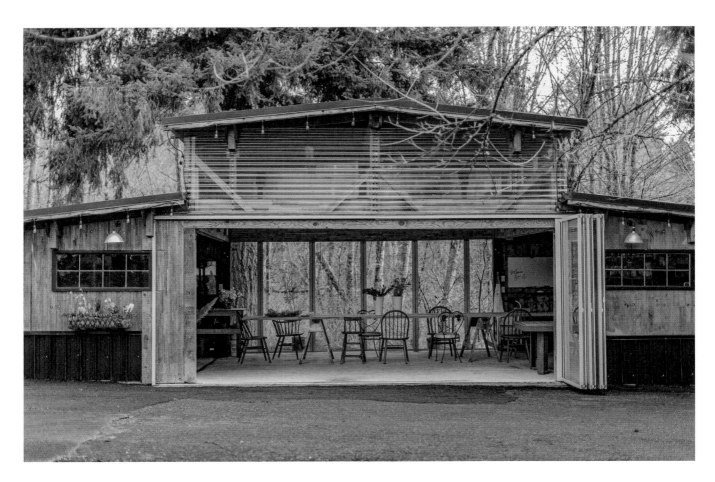

indoor-outdoor

**BUILT WITH SALVAGED PANELS
AND WINDOWS, A SPACIOUS
STUDIO IS HOME TO FLORAL
EDUCATION AND DESIGN**

Sandy Figel, Verbena Floral Seattle

Woodinville, Washington

verbenafloralseattle.com,
@verbenafloralseattle

Missy Palacol Photography

"I like that we didn't have
to go out and spend a lot of
money to make this work."

At the fringes of Seattle in a town called Woodinville, Sandy and Rudy Figel live on seven acres that's one-part sunny and one-part forested. An elementary school teacher, Sandy's "side gig" as a floral designer complements her summers off. In 2015, she made it formal and opened Verbena Floral as a design studio for weddings and events. "I started like a lot of people, designing for friends' and family weddings from my garden," she explains. Her cutting garden occupies approximately three acres, complete with perennial borders, ornamental shrubs, and beds for cut flowers.

"My garden is wonderful for designing delivery arrangements or to add something special to the bride's bouquet or centerpieces," she says. As her studio business matured, Sandy yearned for a dedicated workshop. She asked Rudy to help her create her a "home base" for both production and teaching. "We only have a one-car garage, so I convinced him the building could be half-garage and half-studio," she laughs. "And then, sure enough, I decided to take over the whole thing."

The result of their collaboration is a 400-square-foot shelter with barn-style proportions, perfectly placed in situ to capture views of Sandy's cultivated gardens in one direction and natural greenbelt in the other. Rudy and Sandy value "thriftiness" and have a penchant for salvaged

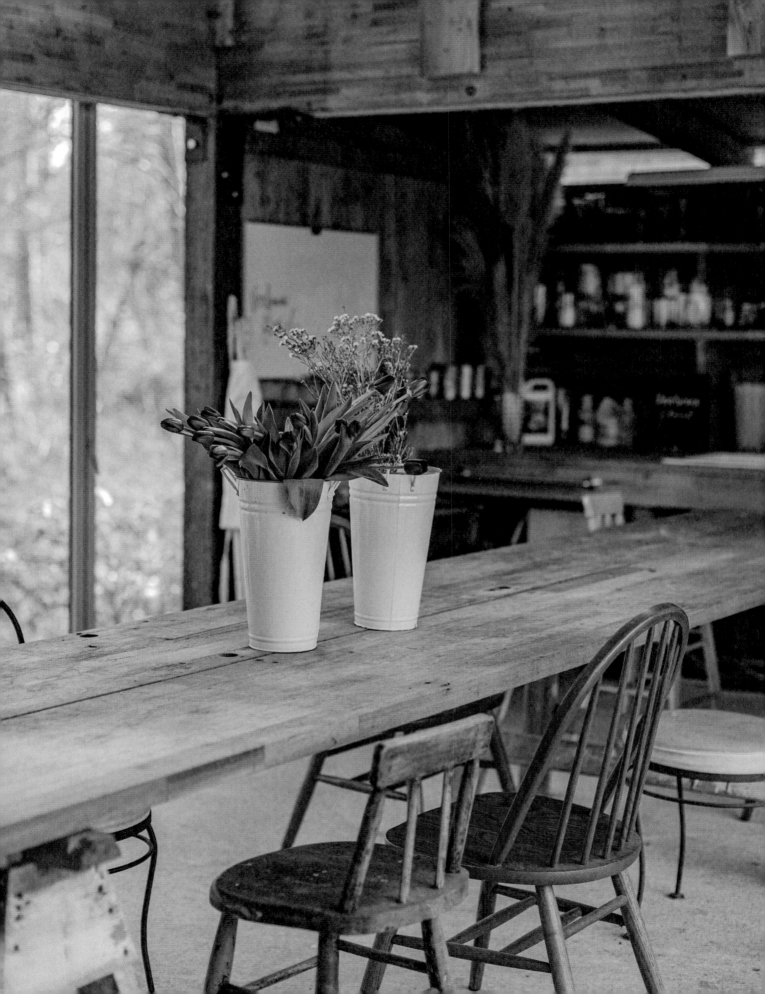

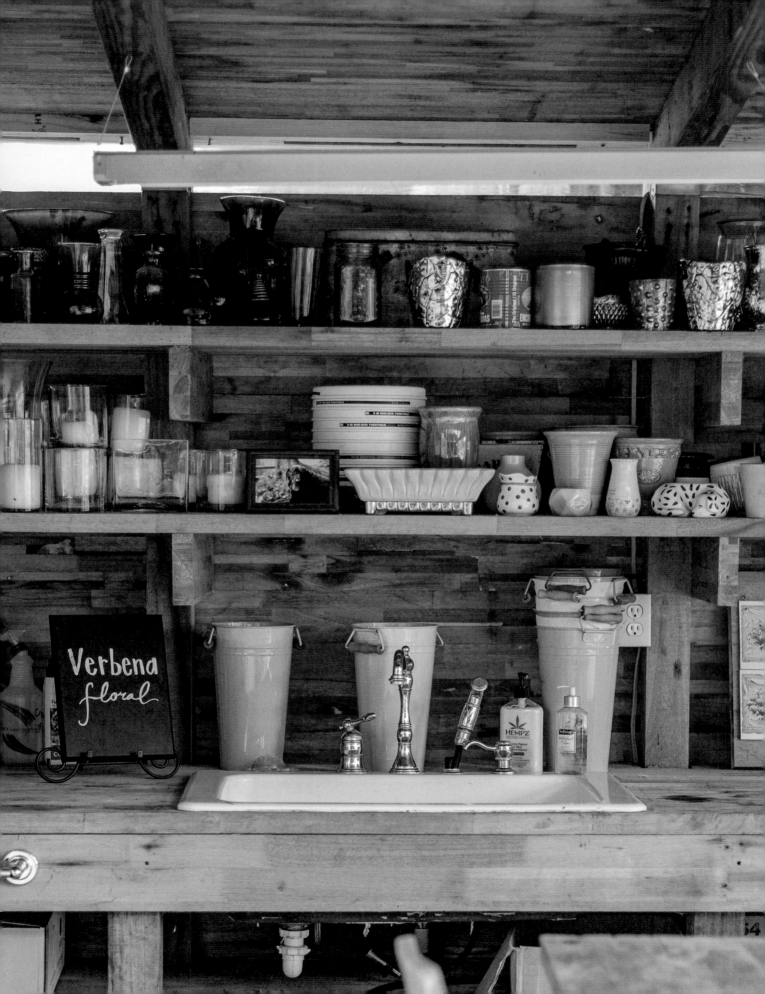

and repurposed materials. These traits influenced the design and construction of their architectural focal point. "Rudy has a source for surplus wood panels that the Boeing Co. originally used to ship airplanes," she says. "The beauty is that they are very economical and are the perfect size to form the studio's walls."

A clerestory emerges from the vaulted roofline, capturing plenty of natural light with corrugated plexi-panels. A standing-seam metal roof is one of the only "new" materials Rudy used. "All our shelving and tables are salvaged, too," Sandy explains. "I like that we didn't have to go out and spend a lot of money to make this work." Originally open to the elements across the front and back sides, the studio gained both functionality and interest when Rudy discovered a set of two green metal-and-glass folding doors at Second Use, a Seattle source for recycled building materials. Sandy suspects the accordion-style panels are original to a 1960s pool house or patio.

Sandy is happiest when her whimsical space is filled with people, either for floral design and seasonal wreath-making workshops or family meals during holidays. An 18-foot-long table, fashioned from sawhorse and boards and Rudy-built, stands at the center. "When the doors are open, we can spill out onto the patio for design projects and classes."

Sandy now contemplates an eventual exit from teaching, knowing that she has an alluring home base to nurture the growth of her floral studio. "Floral design is my passion," she says. "And the studio is my happy place. I enter, turn on music, and start designing."

"When the doors are open, we can spill out onto the patio for design projects and classes."

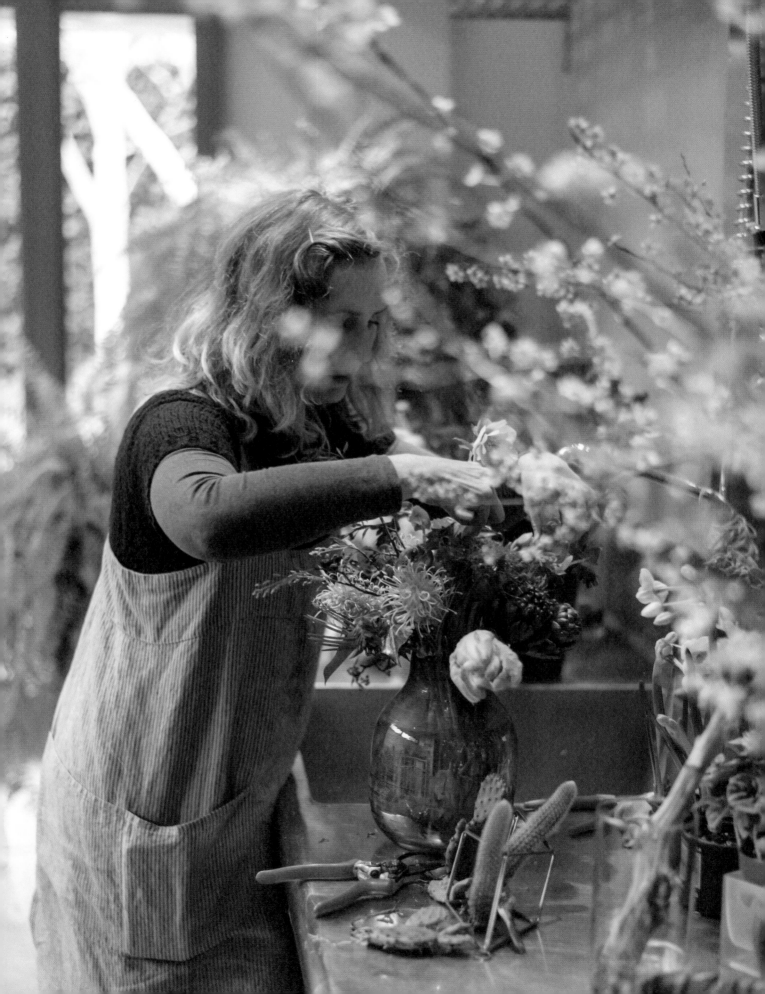

wildly formal

BOTANICALLY GUIDED, LOCALLY SOURCED IN A PACIFIC NORTHWEST GARDEN

TJ Montague, Garden Party Design Inc.

Bainbridge Island, Washington

gardenpartyflowers.com,
@gardenpartyuberflowers

Christina Servin Photography

"The garden provides a visual which leads to trust – sort of a shorthand to my design aesthetic."

Garden Party is based in a midcentury-inspired studio nestled among a quarter acre of flowers, herbs, and trees on Washington's Bainbridge Island, a 35-minute ferry trip from downtown Seattle. Owner TJ Montague and her husband moved here in the early 2000s, spending several years renovating a 1960s house and planting a garden.

TJ established Garden Party in 1995 after earning a Bachelor's degree in environmental design and attending the former London School of Design to study with Nancy Broback, a revered Seattle floral designer who trained and worked with the late Constance Spry (1886-1960). Constance Spry flowered the homes and ceremonies of England's aristocratic clients of her era, often clipping blooms from cottage gardens and perennial borders, a fact not lost a century later on TJ.

"I call myself a 'wild formalist.' I begin with the fundamentals of design and then add some quirky, unexpected, and free-form elements, incorporating color, texture and a wide variety of botanicals from commercial growers, my own garden and the wilds of nature." She doesn't consider herself a farmer-florist, though. "I am a reluctant gardener," TJ laughs. "Being a florist is my passion. But I keep a garden because I want to have certain delicate flower varieties onsite, as well as a lot of different types of greenery — the type that make people say, 'Wow, I haven't seen that before.'"

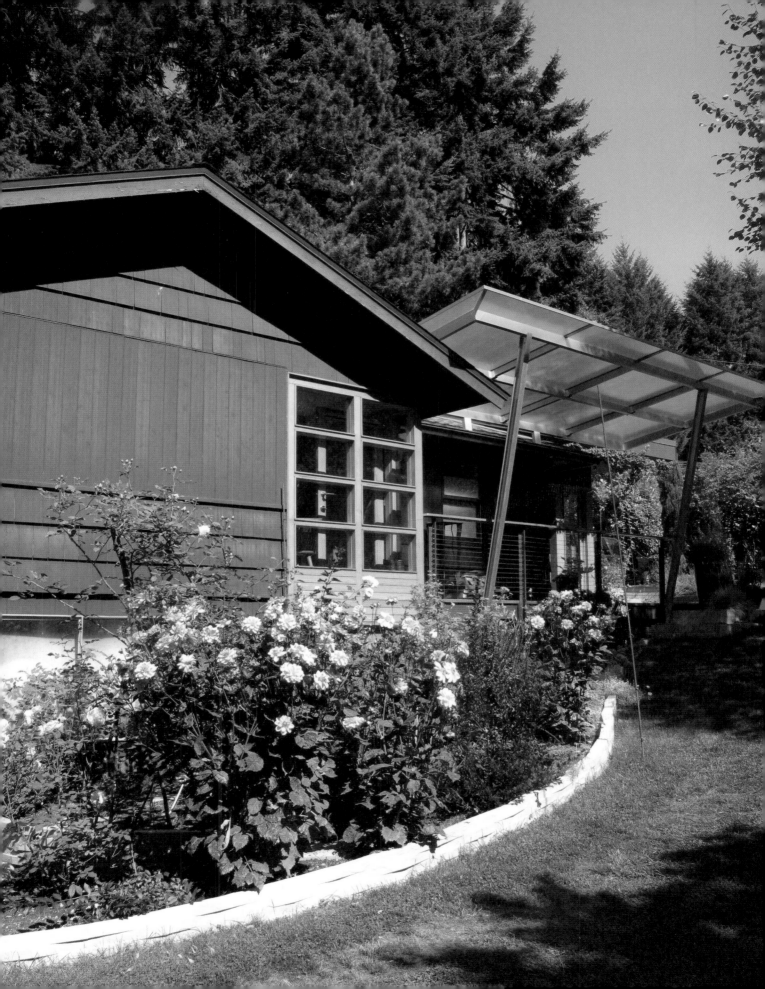

A decade ago, TJ felt the impetus to move out of her costly Seattle design studio. "The lease kept going up," TJ explains. "I was designing five or six weddings each weekend and it felt like I was using all of my income to pay for people to help me and to cover my lease. I knew I had to figure out how to make my life different."

Sanity and a financial solution soon stood before her eyes — the decaying carport covered by a tarp and used for storage. It's amazing to view the studio today, transformed with salvaged fir windows and doors and clad in a verdant *Akebia* vine. TJ and her husband shopped for recycled building materials and installed a salvaged skylight, which drenches the interior in natural light. They rescued a stainless-steel restaurant sink covered in grease and soot from a fire. Now polished, the sink stands against a eucalyptus green accent wall.

Clients who arrive for consultations walk through a gate, past a tall hedge, and step into a serene entry garden as they approach the studio. "When clients enter our garden and love what they see, they often hire me to be their wedding florist. The garden provides a visual which leads to trust — sort of a shorthand to my aesthetic," TJ explains.

Garden Party Design's roots have sunk deeper into Bainbridge Island. More clients are drawn to wedding venues on nearby Kitsap and Olympic Peninsulas, meaning TJ's flowers stay closer to home. She has recently expanded a daily floral delivery service, an intentional way to connect further with her community. "I want to love what I do and love my life," TJ says.

"I call myself a 'wild formalist.' I begin with the fundamentals of design and then add some quirky, unexpected, and free-form elements, incorporating color, texture, and a wide variety of botanicals from commercial growers, my own garden, and the wilds of nature."

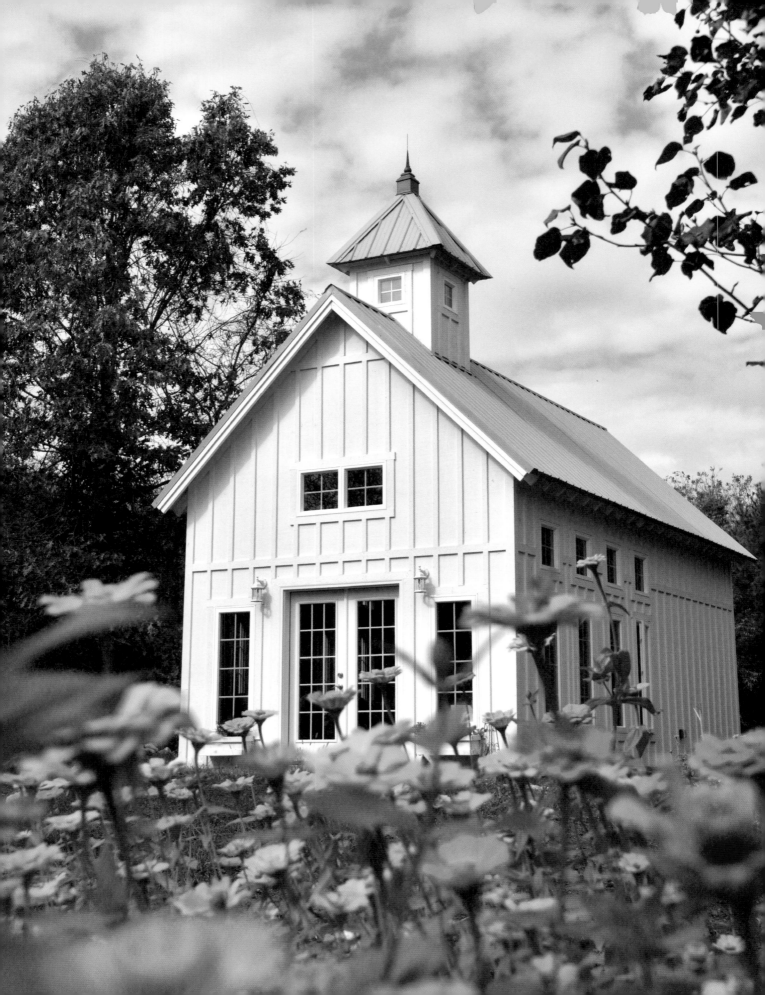

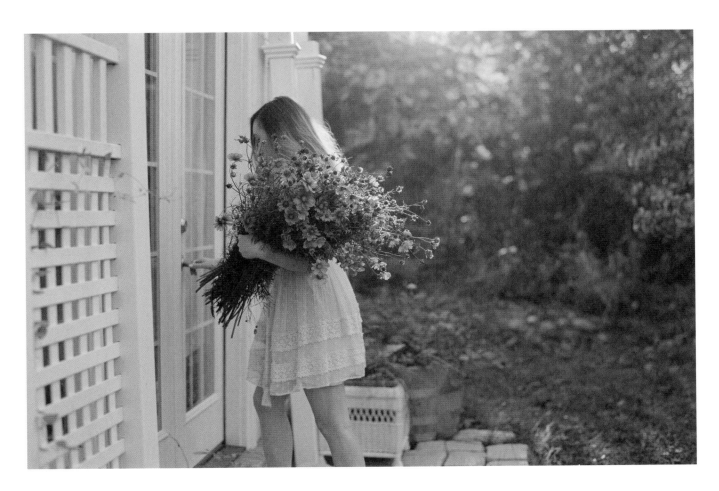

cottage charm

A FLOWER FARM LURING FLORISTS AND WEDDING PHOTOGRAPHERS ALIKE

Kelly Hill,
Blossom Thyme Hill Flower Farm

Nixa, Missouri

blossomthymehillflowerfarm.com,
@blossomthymehill

Kelly Hill Photography

Wildflowers bloom in Nixa, Missouri, where Kelly Hill once grew and preserved antique garden roses for handmade wreaths she sold at craft fairs in the 1990s.

Today, after a few decades raising her children, Kelly has returned to floral art. She has transformed her family's five acres into Blossom Thyme Hill Flower Farm, a boutique flower farm growing specialty cut and heirloom flowers using sustainable and natural practices in the Missouri Ozarks outside Springfield.

The property is surrounded by forested land, and at its heart is a charming Amish-built cottage with flowering pear and crabapple trees and drifts of perennials growing nearby. The inspiration to build the 14-by-20-foot structure began years ago when Kelly started a folder of magazine clippings about sheds and cottages. She originally imagined having a play cottage for her daughter Shelby, but time and resources never aligned to make it a reality. "I also dreamed of having my own creative space, a perfect place for making my dried flower wreaths," Kelly recalls.

In 2015, the little girl was "grown up" engaged and ready to wed her fiancé, Jared Lung. With images of that playhouse still in her imagination, Kelly and her husband Robert Hill decided to use a small

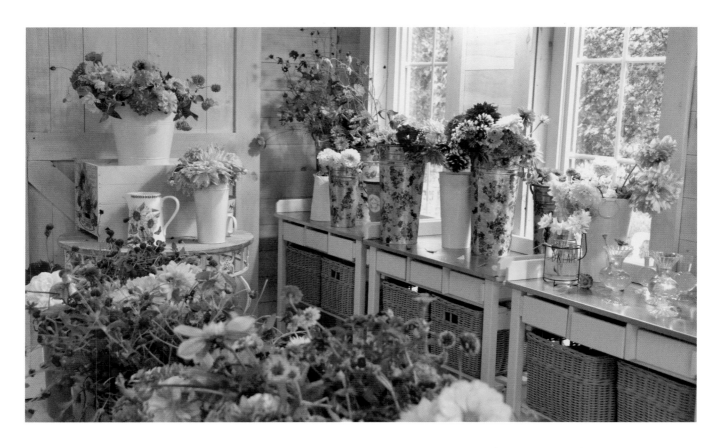

"My life has come full circle, back to where my love affair began with flowers."

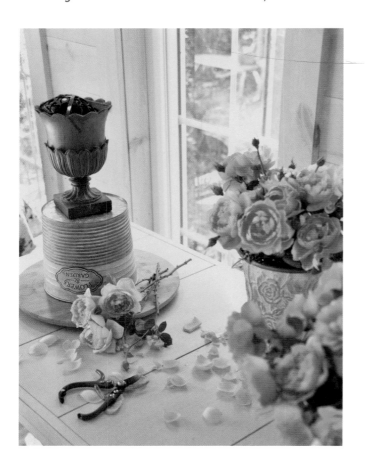

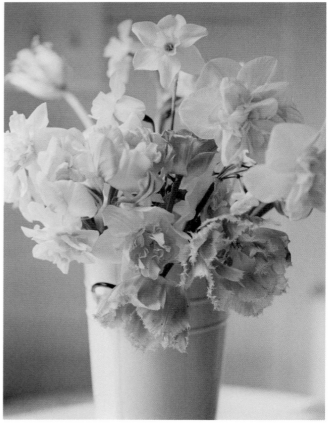

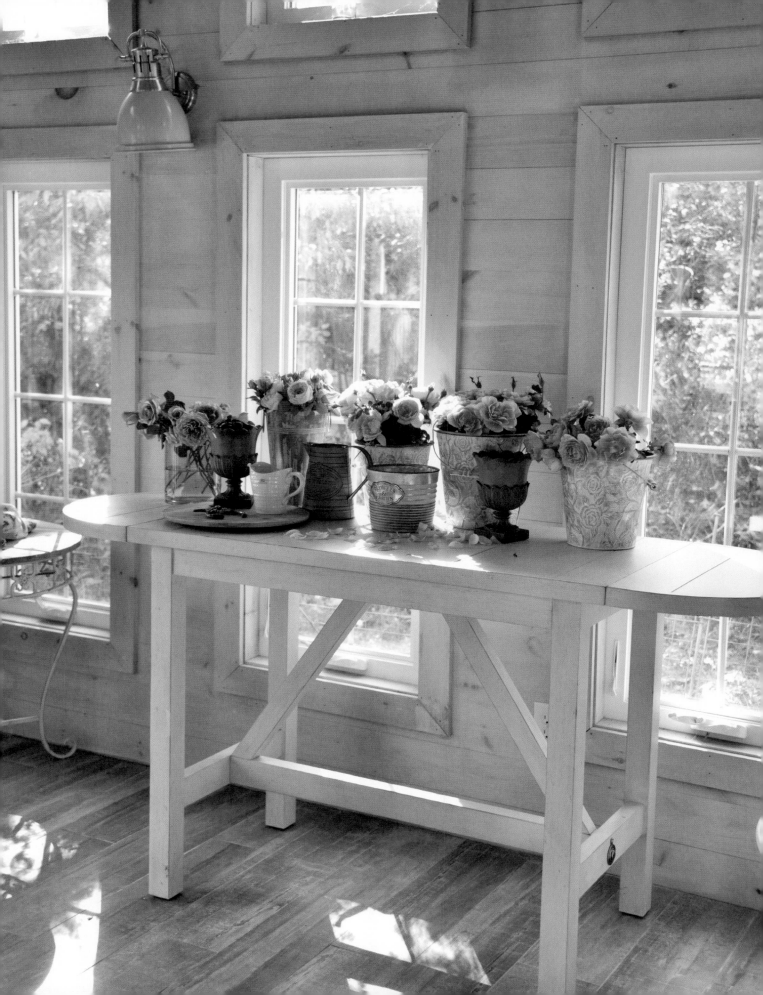

inheritance to build a charming cottage next to the wildflower fields, just in time for the nuptials. The inviting structure has tall windows and a whimsical cupola — straight out of a storybook.

"On that beautiful June day, Shelby and Jared had their first-look photographs taken outside of the cottage," Kelly recalls. "She opened the doors and walked out to surprise him. They strolled to the wildflower field and had their moment together while being filmed."

Owners of Shea Brianne Photography (see page 81), the young couple collaborates as graphic designers and destination wedding photographers. It's no surprise their event-planner friends have inquired about using the cottage for styled shoots.

"Our mission is to provide a haven for people to come and relax, to experience something wonderful, and to bring a smile to their faces."

This led to Kelly also saying "yes" when wedding photographers asked to take "first look" portraits in the cottage garden with the white-clad structure as focal point. Blossom Thyme Hill Farm also added flower workshops for adults and children, and began selling cut flowers to designers, as well as renting the cottage for elopements, parties, and photography. Kelly and Shelby are currently collaborating on a line of flower seeds to offer customers.

"Our mission is to provide a haven for people to come and relax, to experience something wonderful, and to bring a smile to their faces," Kelly explains. "We want to nurture connection and community in a stressful world. We want to make a positive mark and hopefully encourage others to leave a positive mark on the earth. And we want children to know and experience the wonders of this beautiful planet."

Transitioning to a career as a both floral designer and flower farmer happened naturally for Kelly, as her abundant cutting garden provided plenty of blooms for local customers, small conferences, and events in the area. She found it easy to draw from her past dried-flower crafting business, thanks to her garden's vintage roses and peonies, to new fields where heirloom annuals, perennials, and herbs now flourish.

"My life has come full circle, back to where my love affair began with flowers," she says. "It is so fun to see how excited people get about the cottage and the flower farm. At this season of my life with a near-empty nest, I'm so fortunate to share this place with other people and bring them joy through flowers."

resources

CAL ✿ FLOWERS™

California Association of Flower Growers & Shippers

More Americans Enjoying
More Flowers More Often

CalFlowers is the leading floral trade association in California, providing valuable transportation and other benefits to flower growers and the entire floral supply chain in California and 48 other states. The Association's industry-leading transportation programs are designed to ship flowers, foliage, and produce at incredible discounts. These best-in-class programs can significantly expand members' markets and access new business opportunities.

CalFlowers does so much more! We also sponsor J Schwanke's Life in Bloom television show, the Memorial Day Flower Foundation, AIFD Symposium, and the ever-growing CalFlowers Scholarship Fund through American Floral Endowment.

cafgs.org
1588 South Mission Road, Suite 100
Fallbrook, CA 92028
831-479-4912 ext. 2

Serving Growers Since 1973

johnnyseeds.com | 877-565-6687

Online Marketplace for Local Flower
Farmers and Floral Buyers

rootedfarmers.com

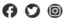 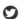 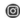

About Debra Prinzing

Debra Prinzing is a Seattle-based writer, speaker and leading advocate for local and domestic flowers. Through Slow Flowers Society's many channels and programs she encourages consumers and professionals alike to make conscious choices about their floral purchases. Debra is the producer of SlowFlowers.com, the weekly "Slow Flowers Podcast" and the American Flowers Week (June 28-July 4) campaign. She is author of 12 books, including *The 50 Mile Bouquet* and *Slow Flowers Journal*.

slowflowerssociety.com

About BLOOM Imprint

BLOOM Imprint was founded in 2020 by Robin Avni and Debra Prinzing. Between them, the women have produced and published more than 20 lifestyle, design, architecture, floral and gardening titles. They formed BLOOM Imprint as a boutique publishing company with the mission of identifying creative entrepreneurial book ideas and growing them — from the seed of an initial concept to a finished product.

bloomimprint.com

"Life begins the day you start a garden."

CHINESE PROVERB